LOOKING

LOOKING

AT PICTURES

KENNETH CLARK

JOHN MURRAY
50 Albemarle Street
LONDON

First published October 1960
Fourth impression 1970
This edition 1972
Printed in Great Britain
Colour illustrations by Henry Stone Ltd Banbury
Monochrome blocks made by Garrett and Atkinson Ltd
Text and monochrome illustrations printed
by R. and R. Clark Ltd Edinburgh
Bound by Hunter & Foulis Ltd Edinburgh
0 7195 2704 X

To the memory of

ROGER FRY

who taught my generation
how to look

CONTENTS

Contents

ILLUSTRATIONS

In Colour

In Monochrome

Illustrations

Illustrations

Illustrations

ACKNOWLEDGEMENTS

I HAVE TO ACKNOWLEDGE my indebtedness to Her Majesty the Queen for gracious permission to reproduce drawings from the Royal Library, Windsor Castle, two of the Raphael cartoons from the Victoria and Albert Museum, and Vermeer's *A Lady at the Virginals*.

My thanks are due to Christabel, Lady Aberconway, the Earl of Ellesmere, Miss Ursula Frere, Miss Beryl Frere, S. A. Morrison, Esq., and Mrs Woodall, for allowing me to reproduce pictures from their collections, and also to the curators of the following museums and galleries:

The Louvre, Paris; The Prado, Madrid; Museum of Fine Art, Boston; The Victoria and Albert Museum, London; The State Museum, Berlin-Dahlem; The Herzog Anton Ulrich Museum, Brunswick; The Musée Cognacq-Jay, Paris; Kunsthistorisches Museum, Vienna; The National Gallery, London; The National Gallery of Art (Widener Collection), Washington, D.C.; The National Gallery of Scotland, Edinburgh; The Municipal Gallery, Montpellier; The Uffizi Gallery, Florence; The Museo de S. Vicente, Toledo; The British Museum; Gemäldegalerie, Dresden; The Städelsches Kunstinstitut, Frankfurt a.M.; The Iveagh Bequest, Kenwood; The College Governors of Alleyn's College of God's Gift, Dulwich; The Städtische Kunsthalle, Mannheim; and The Vatican Museum, Rome.

I would also like to thank Fine Art Photography Ltd, who supplied all but one of the colour transparencies and many of the monochrome prints, and the following who have supplied prints:

The Mansell Collection, London; Anderson, Rome; J. E. Bulloz, Paris; Osvaldo Bohm, Venice; Messrs A. C. Cooper Ltd, London; Danesi, Rome; Ampliciones y Reproducciones Mas, Barcelona; The Phaidon Press Ltd; Walter Steinkopf, Berlin-Dahlem; Giraudon, Paris; The Courtauld Institute of Art; The Lefevre Gallery; Annan, Glasgow; The London County Council (Architect's Department); Vizzavona, Paris; and Mme M. Hours, author of *A la Découverte de la Peinture* (Arts et Métiers Graphiques, Paris).

INTRODUCTION

No DOUBT there are many ways of looking at pictures, none of which can be called the right way. Those great artists of the past who have left us their opinions on painting—Leonardo da Vinci, Dürer, Poussin, Reynolds, Delacroix—often gave reasons for their preferences, with which no living artist would agree; and the same is true of the great critics—Vasari, Lomazzo, Ruskin, Baudelaire. Yet they lived at a time when the standard of painting was higher than it is today, and they thought of criticism as a more exacting profession than do most contemporary critics. They admired, more or less, the same works of art; but in their criteria of judgement they differed from each other even more than the painters, who at least had in common certain technical problems. The once fashionable phrase 'he likes it for the wrong reasons' exposes not only arrogance, but ignorance of history.

But this is not to admit that the opposite character, the man who professes to 'know what he likes' by the light of nature, is right in this, or any, field. No one says that about any subject to which they have devoted some thought and experienced the hazards of commitment. Long practice in any occupation produces a modicum of skill. One can learn to cook and play golf—not, perhaps, very well, but much better than if one had refused to learn at all. I believe one can learn to interrogate a picture in such a way as to intensify and prolong the pleasure it gives one; and if (as all those great men whose names I have just quoted would certainly have agreed) art must do something more than give pleasure, then 'knowing what one likes' will not get one very far. Art is not a lollipop, or even a glass of kümmel. The meaning of a great work of art, or the little of it that we can understand, must be related to our own life in such a way as to increase our energy of spirit. Looking at pictures requires active participation, and, in the early stages, a certain amount of discipline.

Introduction

I do not suppose that there are any rules for this exercise; but perhaps the experiences of a confirmed lover of painting may be some guide, and this is what I offer in the essays that follow. I have set down, as accurately as I could, the course of my feelings and thoughts before sixteen great paintings. They have been chosen from as wide a range as possible, so that my responses have varied considerably. Sometimes, as in *Las Meniñas*, the subject comes first; sometimes, as with Delacroix, knowledge of the artist's character determines my attitude to his work. But on the whole I have found that my feelings fall into the same pattern of impact, scrutiny, recollection and renewal.

First I see the picture as a whole, and long before I can recognise the subject I am conscious of a general impression, which depends on the relationship of tone and area, shape and colour. This impact is immediate, and I can truthfully say that I would experience it on a bus going at thirty miles an hour if a great picture were in a shop window.

I must also admit that the experience has sometimes been disappointing: I have jumped off the bus and walked back, only to find my first impression betrayed by a lack of skill or curiosity in the execution. So the first shock must be followed by a period of inspection in which I look from one part to another, enjoying those places where the colour is harmonious and the drawing grips the things seen; and naturally I become aware of what the painter has intended to represent. If he has done so skilfully this adds to my enjoyment, and may, for a moment or two, deflect my attention from pictorial qualities to the subject. But quite soon my critical faculties begin to operate, and I find myself looking for some dominating motive, or root idea, from which the picture derives its overall effect.

In the middle of this exercise my senses will probably begin to tire, and if I am to go on looking responsively I must fortify myself with nips of information. I fancy that one cannot enjoy a pure aesthetic sensation (so-called) for longer than one can enjoy the smell of an orange, which in my case is less than two minutes; but one must look attentively at a great work of art for longer than that, and the value of

historical criticism is that it keeps the attention fixed on the work while the senses have time to get a second wind. As I remember the facts of a painter's life and try to fit the picture in front of me into its place in his development, and speculate as to whether certain parts were painted by an assistant or damaged by a restorer, my powers of receptivity are gradually renewing themselves, and suddenly make me aware of a beautiful passage of drawing or colour which I should have overlooked had not an intellectual pretext kept my eye unconsciously engaged.

Finally I become saturated with the work, so that everything I see contributes to it, or is coloured by it. I find myself looking at my room as if it were a Vermeer, I see the milkman as a donor by Rogier van der Weyden, and the logs on the fire crumble into the forms of Titian's *Entombment*. But these great works are deep. The more I try to penetrate them the more conscious I become that their central essences are hidden far further down. I have only scratched the surface with the worn-out instrument of words. For, quite apart from shortcomings of perception, there is the difficulty of turning visual experiences into language.

Some of the greatest masterpieces leave us with nothing to say. Raphael's *Sistine Madonna* is undoubtedly one of the most beautiful pictures in the world, and I have looked at it with what our grand-parents would have called 'elevated feelings' day after day for months; but the few banal thoughts it has aroused in my mind would not fill a postcard. In choosing subjects for these essays, therefore, I had to be sure that they were pictures about which something could be said without too much padding, rhetoric or whimsy. There were other limiting factors. I had to avoid painters—Piero della Francesca, for example—about whom I had written a good deal already; and for the same reason I have not included any pictures of the nude, although this has deprived me of the pleasure of writing about Rubens. Some pictures I greatly admire are inaccessible; and some, like Giotto's frescoes in the Arena Chapel, should not be considered out of their

context. To choose pictures with a subject was perhaps inevitable: for what, after all, can one say, except in front of the original, about a Cézanne still life, which depends for its nobility on the exact tone and character of every touch. As a result I fear that illustration has been made to seem more important than it is, simply because it is easier to render in words.

All but one of these essays first appeared in *The Sunday Times* and my thanks are due to the Editor for allowing me to reprint them. They were designed to occupy one page and to be of a weight and consistency that would not be out of keeping with the rest of the paper. For some reason a piece which makes quite a substantial effect on the page of a newspaper seems to shrink when bound between boards. The essays which follow seem much shorter than they did when surrounded by advertisements; in fact they have nearly all been considerably lengthened.

The book is dedicated to the memory of Roger Fry. He would have disagreed with much that I say and would have been slightly shocked to find that I have included works by Turner and Delacroix, painters to whom his mind was resolutely closed. But I remember that he listened eagerly to the most outrageous opinions; and it was in following his magical unfolding of Poussin's *Triumph of David* or Cézanne's *Compotier* that I first became aware of how much can be discovered in a picture after the moment of amateurish delight has passed.

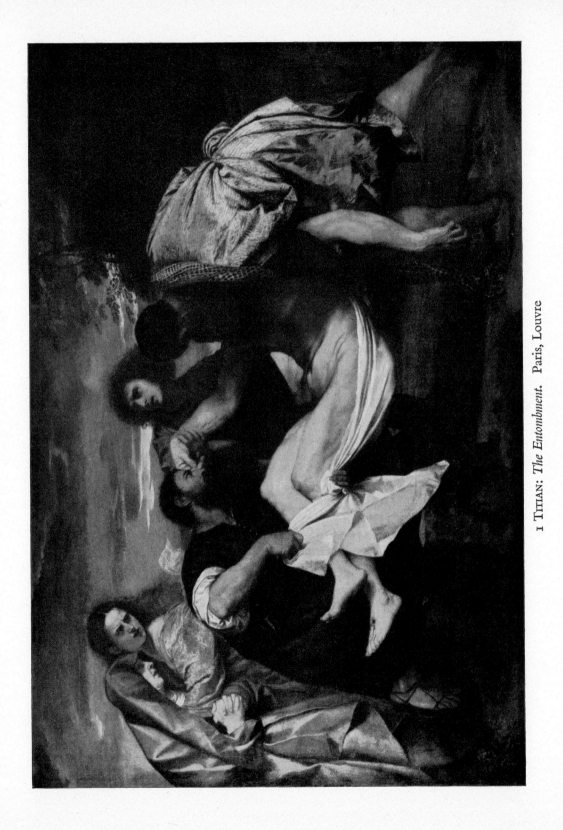

1 TITIAN: *The Entombment.* Paris, Louvre

TITIAN

The Entombment

FROM FAR AWAY the assault on my emotions is immediate and commanding, like one of the great first lines of Milton—'Of Man's first disobedience' or 'Avenge, oh Lord, Thy slaughter'd saints'—and in this state of heightened feeling I cannot distinguish, any more than Titian could, between the drama of the subject and the drama of light and shade. His root idea was concerned equally with both. It was that the pale body of Christ, borne on a white sheet, should hang in a pool of darkness, as if in a human cave; and that beyond this cave should be two buttresses of vibrating colour. The crimson robe of Nicodemus and the balancing blue of the Virgin's cloak would not only make more precious, by contrast, the body of Christ, but would produce in us a sense of harmony through which the tragedy might become tolerable.

All this I recognise in the first second, for Titian is strong enough to prefer a frontal attack, and never leaves one long in doubt about his chief intentions; but as soon as I examine the composition more closely I begin to realise how subtly the magnificent obviousness of the main idea is modified in the execution. I notice, for example, that the actual form of Christ's body, the form that we know to be there, plays little part in the design. The head and shoulders are lost in shadow, and the dominant shapes are given by the knees, the feet and the white linen folded over the legs. These are thin, irregular triangles—a torn paper shape—and they extend from the winding-sheet to the Virgin's drapery and, indeed, to the composition of the whole group.

Titian

It is always doubtful how far a painter consciously develops a shape, as a musician creates a whole movement by developing a single rhythmic phrase. The art of painting is much less cerebral; often the hand takes charge, imposing a certain rhythm without the intellect being aware of it. And as such thoughts pass through my mind I remember the description, by his most trusted pupil, Palma Giovane, of Titian at work: how he would rough in the whole design in broad masses, then turn the canvas to the wall; then, when the desire returned, attack it again with equal freedom, and once more relinquish it. Thus he maintained to the last the passionate eagerness and the instinctive rhythms of the first sketch, ending, Palma tells us, by painting more with his fingers than his brush. Already in the *Entombment* (painted long before Palma's time) there are passages, like the lining of Nicodemus' cloak, where Titian communicates with us directly through the movement of his brush, and others when we feel sure that instinct, not calculation, was responsible. Indeed the quality of living paint, which raises these draperies from a decoration to a declaration of faith, could not have been achieved by technical skill alone.

But while my memory is still playing round these questions of pictorial means, my thoughts are deflected by the arm of Joseph of Arimathea, almost aggressively solid and alive. By the juxtaposition of this sunburnt arm with Christ's lunar body Titian takes me back from the contemplation of colour, shadow and shape and fixes my attention on the figures themselves. My eye passes to the head of the St John at the summit of the pyramid, and as I pause for a second, enchanted by his romantic beauty, the thought crosses my mind that he is like a memory of Titian's youthful companion, the fabulous Giorgione, whose self-portrait has come down to us in various copies. But his gaze, with mounting emotion, directs my eye away from the central group towards the figures of the Virgin and St Mary Magdalene. Here the solemn drama of the weight-bearing men takes on a new urgency. St Mary turns away in horror, yet cannot withdraw her eyes; the Virgin, with hands tensely clasped, gazes at the body of

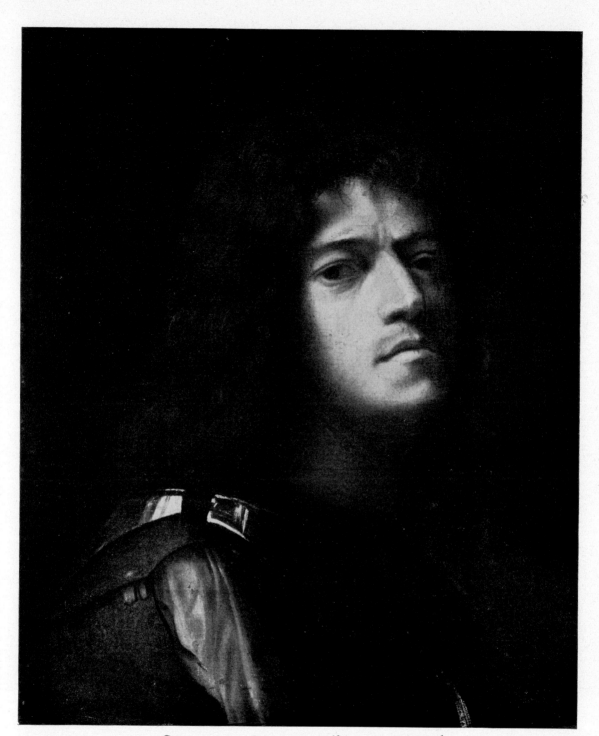

2 COPY OF A LOST GIORGIONE: *Self-Portrait*. Brunswick

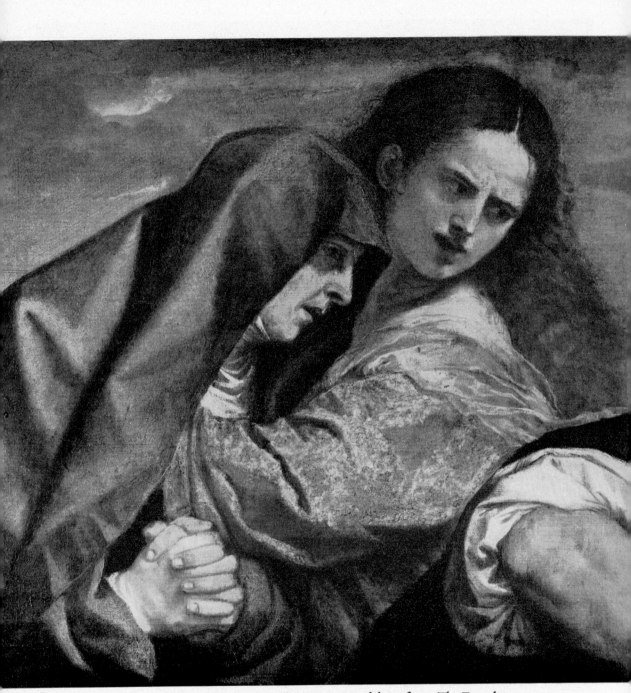

3 TITIAN: The Virgin Mary and St Mary Magdalene, from *The Entombment*

her son. It is one of those obvious, eloquent appeals to our emotions of which the great Italians, from Giotto to Verdi, have been the masters; and woe to him who cannot respond. He is cut off from one of the few artistic experiences which can be shared with the majority of our fellow-men.

This power to touch popular emotions, so often disgustingly abused, demands from a great artist some special human qualities. What is it that Handel and Beethoven, Rembrandt and Breughel, have in common and that other artists of almost equal genius seem to lack? As this question develops in my mind, it distracts me from the concentrated shock of Titian's picture, and I pause to recall what I can remember about his life and character.

He came to Venice from the mountain village of Cadore in the early years of the sixteenth century, determined to succeed. Like many of the greatest painters, Titian does not fit in with our romantic ideas of what an artist should be. He had to an almost embarrassing degree the discredited virtue of *prudentia*. His earliest letters are an attempt to persuade the Grand Council of Venice to dismiss his venerable master, Giovanni Bellini, who had been intolerably slow in decorating the Ducal Palace, and give him the job instead. His subsequent correspondence, which is chiefly addressed to reigning princes or their agents, is in the style of the grossest flattery, imitated from that of his friend, Pietro Aretino. As is usual with painters (for why else should they bother to write letters?), it is concerned with money, but it is exceptional in that it was effective. Titian was paid. His life was one long—very long—success story. As a matter of fact it was not quite as long as he pretended; for in order to soften the heart of Philip II he referred to himself in 1571 as an old man of ninety-five, whereas it now seems almost certain that he was ten years younger. However, he did live to be over ninety, and painted with increasing mastery and freedom to the end. Of this almost monstrous vitality the gossips of the time gave startling instances, which, true or false, tell us little more about him than we can deduce from his handling

of paint. We can feel it, too, in the almost Tolstoyan appetite for humanity which is revealed in his portraits. 'What a rare old mouser he was,' said Northcote, looking at one of those likenesses in which he has pounced on his sitter and held him with a tigerish grip.

Surprisingly, to our protestant minds, this confidence in the physical world was combined with an ardent, orthodox faith in Christianity. One of his first great designs (known to us only through a wood-cut) represented the Triumph of Faith, and he remained throughout his life an exponent of doctrine, for whom the delicacy of an individual conscience was superfluous and distasteful. Ultimately he became the friend as well as the favourite painter of Philip II. We have so often been told that religious feeling is a symptom of neurosis or maladjustment that it is something of a shock to find this superbly efficient male animal thinking of the Passion of Our Lord or the Assumption of the Virgin as realities—events which actually distressed or elated him. But Titian's religious pictures convince us that this was so. They are as concrete as his pagan ones, and painted with even greater conviction.

As always with Titian, the attempt to dwell upon his life has led back to his works, and I am ready to look at the *Entombment* with fresh delight. At this point I find my pleasure increased if I can place a picture in an artist's development, and although the *Entombment* is not dated or documented, one can be fairly sure when it was painted. It cannot be before the huge *Assumption* in the Frari, which was begun in 1518; but St John is so like the Apostles who look up at the ascending Virgin that it cannot be much later. It belonged to the Duke of Mantua, with whom Titian first had dealings in 1521, and was probably one of his first commissions.

The *Assumption* had anticipated, both in sentiment and design, the baroque style of the Counter-Reformation; the *Entombment*, in design at least, is a return to classicism. Though less obviously an antiquary than Raphael, Titian was a passionate student of antique sculpture and

I TITIAN: Detail of St John's head, from *The Entombment*

the starting-point of this design has been some Hellenistic sarcophagus of the death of Hector or Meleager. I can tell this both from the pose of the Christ, with arm hanging limp, and from the way in which the figures are arranged in one plane, and fill the whole space exactly as they do on an antique relief. Raphael had taken an antique of this subject as the inspiration of the *Entombment* which he had painted for Atalanta Baglione about ten years earlier; and perhaps Titian, who had a keen sense of competition, had it in mind to surpass this great work, the fame of which must have reached, and displeased, him. If so, he succeeded, for his *Entombment* is not only richer and more passionate, but closer to the spirit of Greek art than Raphael's rather mannered masterpiece. Its classical fullness of design was, indeed, so contrary to baroque taste that one of its owners, probably Charles I, who bought it from the Palace of Mantua, had the canvas enlarged, and to realise Titian's original intention one must cut about eight inches off the top of the picture.

The discovery that Titian has taken his design from an antique relief helps me towards a clearer definition of his style. More than any other great painter, he combined a desire to render the warmth of flesh and blood and a need to fulfil the dictates of the ideal. His vision strikes a balance between free will and determinism. An example in the *Entombment* is Our Lord's left arm. Its position in the design, even its outline, is controlled by an ideal prototype; but the actual painting shows a sensitive perception of truth which has not been surpassed. One can see the same procedure in the *Sacred and Profane Love*, where the nude figure is like an antique Venus magically turned back into living flesh.

Titian's contemporaries, whose critical values were drawn from a diluted Platonism, took his idealising faculty for granted and dwelt chiefly on his powers to give his figures life. We, with eyes conditioned by the camera, may feel the reverse. Only in a few of his portraits do we think first of the living model; and often, as in his *Venus and the Organ Player*, his sense of formal necessities strains our

credulity. The *Entombment* is convincing; but it remains a construction of art, in some ways as artificial as an operatic quintet; and I find myself impiously allocating the parts—basso, baritone, tenor, soprano and contralto—to the five protagonists. The fact that they fit so perfectly proves that the symbolic figures of opera are more comprehensive than one might suppose, and are the result of long experience in simplifying the collision of human emotions. All the same, this operatic analogy suggests some need for display which Titian was later to transcend. One does not think of a quintet before the late *Entombment* in the Prado, where the figures are swept together by a rushing mighty wind of emotion; and to that extent it is the greater picture.

Perhaps it is the very completeness of Titian's mature style, with its balance of means and ends, artifice and truth, which makes some of his masterpieces alien to modern taste. They are too polished and prosperous-looking for our splintered civilisation. We are more at ease with the stiff sincerity of earlier gestures or with the agitated rhetoric of the Baroque; and among Titian's own works we prefer the latest paintings—the St Salvatore *Annunciation* or the Hermitage *St Sebastian*—where the paint is driven about the canvas with such heat that it seems to smoulder and burst into flame.

Titian can afford such changes of taste. Like Shakespeare, he bequeathed wealth enough for each generation to stake out a different claim. Nevertheless, I do not believe that any sincere lover of painting has stood unmoved before the *Entombment* since the day it was painted, and although the reason he would have given for his emotion would have varied from century to century, its cause would have remained fundamentally the same.

The Entombment, by Tiziano Vecelli, called Titian (c. 1487–1576), is in oils on canvas, $58\frac{1}{4}'' \times 80\frac{3}{4}''$ (1.48 × 2.05 m.). Sold from the Mantua collection to Charles I in 1628. In the sale of Charles I's collection by the Commonwealth it fetched £120; it was subsequently sold by Jabach to Louis XIV for 3,200 francs, and passed with the French royal collection to the Louvre.

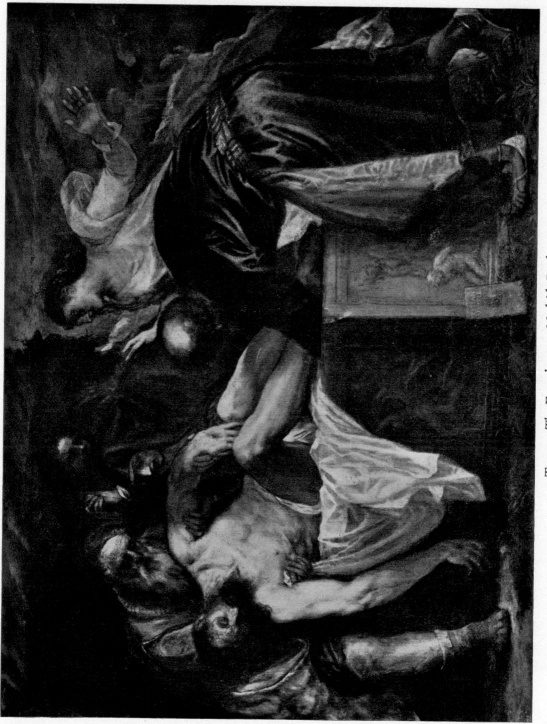

4 TITIAN: *The Entombment.* Madrid, Prado

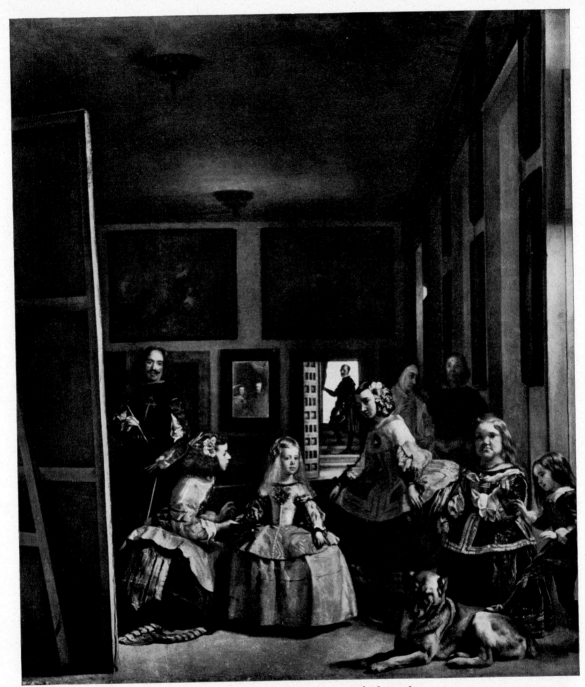

5 VELASQUEZ: *Las Meniñas.* Madrid, Prado

VELASQUEZ

Las Meniñas

OUR FIRST FEELING is of being there. We are standing just
to the right of the King and Queen, whose reflections we can
see in the distant mirror, looking down an austere room in the
Alcazar (hung with del Mazo's copies of Rubens) and watching a familiar
situation. The Infanta Doña Margarita doesn't want to pose. She has
been painted by Velasquez ever since she could stand. She is now five
years old, and she has had enough. But this is to be something
different; an enormous picture, so big that it stands on the floor, in
which she is going to appear with her parents; and somehow the
Infanta must be persuaded. Her ladies-in-waiting, known by the
Portuguese name of *meniñas*, are doing their best to cajole her, and have
brought her dwarfs, Maribárbola and Nicolasito, to amuse her. But
in fact they alarm her almost as much as they alarm us, and it will
be some time before the sitting can take place. So far as we know, the
huge official portrait was never painted.

After all that has been written about the nature of art, it seems
rather absurd to begin by considering a great picture as a record of
something that really happened. I can't help it. That is my first
impression, and I should be slightly sceptical of anyone who said that
they felt anything else.

Of course, we do not have to look for long before recognising
that the world of appearances has been politely put in its place. The
canvas has been divided into quarters horizontally and sevenths verti-
cally. The *meniñas* and the dwarfs form a triangle of which the base
is one-seventh of the way up, and the apex is four-sevenths; and

within the large triangle are three subsidiary ones, of which the little Infanta is the centre. But these and other devices were commonplaces of workshop tradition. Any Italian hack of the seventeenth century could have done the same, and the result would not have interested us. The extraordinary thing is that these calculations are subordinate to an absolute sense of truth. Nothing is emphasised, nothing forced. Instead of showing us with a whoop of joy how clever, how perceptive or how resourceful he is, Velasquez leaves us to make all these discoveries for ourselves. He does not beckon to the spectator any more than he flatters the sitter. Spanish pride? Well, we have only to imagine the *Meniñas* painted by Goya, who, heaven knows, was Spanish enough, to realise that Velasquez' reserve transcends nationality. His attitude of mind, scrupulous and detached, respecting our feelings and scorning our opinions, might have been encountered in the Greece of Sophocles or the China of Wang Wei.

It seems almost vulgar to ask what he was like, he so carefully effaced himself behind his works; and in fact it is chiefly from them that we must deduce his character. Like Titian, he shows no signs of impulsiveness or non-conformity, and like Titian, his life was apparently one of unbroken success. But there the likeness ends. He lives at a different temperature. We read of no passions, no appetites, no human failings; and equally there are no sensuous images burning in the back of his mind. When he was quite a young man he achieved once or twice a poetic intensity of vision, as in his *Immaculate Conception*, but this passed, as it so often does; or perhaps I should say that it was absorbed into his pursuit of the whole.

He was born in 1599, and commended himself to the King as early as 1623. Thenceforward he rose steadily in the Court service. His all-powerful patron, the Count-Duke of Olivares, was dismissed in 1643, and in the same year Velasquez was promoted to be a Gentleman of the Bedchamber, an Assistant Superintendent of Works and, in 1658, to the horror of the official classes, he was invested with the Order of Santiago. Two years later he died. There is evidence that

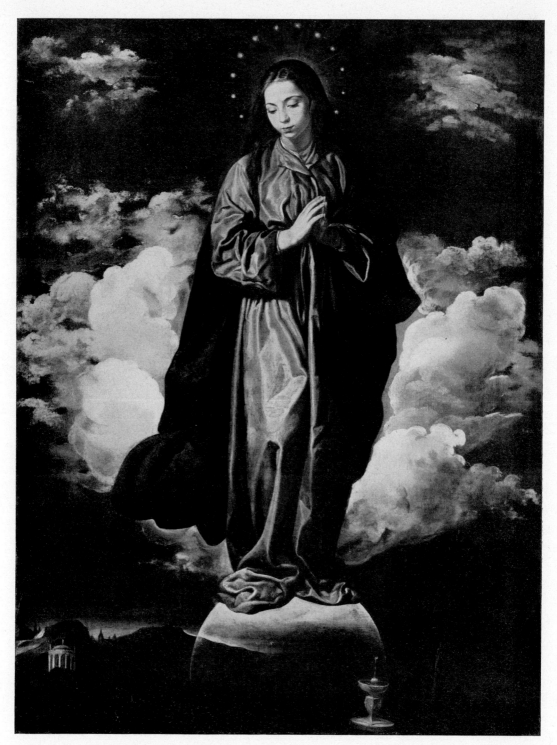

6 VELASQUEZ: *The Immaculate Conception*. London, National Gallery

the royal family regarded him as a friend, yet we read of none of the cabals and jealousies which distorted the lives of Italian painters of the same date. Modesty and sweetness of character would not have been enough to protect him. He must have been a man of remarkable judgement. His mind was occupied almost entirely with problems of painting, and in this, too, he was fortunate, for he had formed a clear idea of what he wanted to do. It was extremely difficult, it took him thirty years of steady work, and in the end he achieved it.

His aim was simply to tell the whole truth about a complete visual impression. Italian theorists, following antiquity, had claimed that this was the end of art as early as the fifteenth century; but they had never really believed it; in fact, they had always qualified it by talking about grace, grandeur, correct proportions and other abstract concepts. Consciously or unconsciously they all believed in the Ideal, and thought that art must bring to perfection what nature had left in the raw. This is one of the most defensible theories of aesthetics ever proposed, but it had no appeal to the Spanish mind. 'History', said Cervantes, 'is something sacred because it is true, and where truth is, God is, truth being an aspect of divinity.' Velasquez recognised the value of ideal art. He bought antiquities for the royal collection, he copied Titian, he was the friend of Rubens. But none of this deflected him from his aim, to tell the whole truth about what he saw.

To some extent this was a technical problem. It is not very difficult to paint a small inanimate object so that it seems real. But when one begins to paint a figure in its setting 'Oh alors!' as Degas said. And to paint a whole group on a large scale in such a way that no one seems too prominent, each is easily related to the other, and all breathe the same air: that requires a most unusual gift.

As we look about us, our eyes proceed from point to point, and whenever they come to rest they are focussed in the centre of an oval pool of colour which grows vaguer and more distorted towards the

7 VELASQUEZ: Himself painting the royal group, from *Las Meniñas*

perimeter. Each focal point involves us in a new set of relations; and to paint a complex group like the *Meniñas*, the painter must carry in his head a single consistent scale of relations which he can apply throughout. He may use all kinds of devices to help him do this— perspective is one of them—but ultimately the truth about a complete visual impression depends on one thing, truth of tone. Drawing may be summary, colour drab, but if the relations of tone are true, the picture will hold. For some reason truth of tone cannot be achieved by trial and error, but seems to be an intuitive—almost a physical— endowment, like absolute pitch in music; and gives, when we perceive it, a pure and timeless pleasure.

Velasquez had this endowment in the highest degree. Every day I look at *Las Meniñas* I find myself exclaiming with delight as I recog- nise the absolute rightness of some passage of tone, the grey skirt of the standing *meniña*, the green skirt of her kneeling companion, the window recess on the right, which is exactly like a Vermeer of the same date, and above all, the painter himself, in his modest, yet confident, penumbra. Only one figure makes me uneasy, the humble-looking attendant (known as a *guardadamas*) behind Maribárbola, who looks transparent; but I think he has suffered from some early restoration; and so has the head of the standing *meniña*, Doña Isabel de Velasco, where the shadows are a little too black. Otherwise everything falls into place like a theorem in Euclid, and wherever we look the whole complex of relations is maintained.

One should be content to accept it without question, but one cannot look for long at *Las Meniñas* without wanting to find out how it is done. I remember that when it hung in Geneva in 1939 I used to go very early in the morning, before the gallery was open, and try to stalk it, as if it really were alive. (This is impossible in the Prado, where the hushed and darkened room in which it hangs is never empty.) I would start from as far away as I could, when the illusion was complete, and come gradually nearer, until suddenly what had been a hand, and a ribbon, and a piece of velvet, dissolved

into a salad of beautiful brush strokes. I thought I might learn something if I could catch the moment at which this transformation took place, but it proved to be as elusive as the moment between waking and sleeping.

Prosaically minded people, from Palomino onwards, have asserted that Velasquez must have used exceptionally long brushes, but the brushes he holds in the *Meniñas* are of normal length, and he also carries a mahlstick, which implies that he put on the last delicate touches from very close to. The fact is that, like all transformations in art, it was not achieved by a technical trick, which can be found out and described, but by a flash of imaginative perception. At the moment when Velasquez' brush turned appearances into paint, he was performing an act of faith which involved his whole being.

Velasquez himself would have repudiated such a high-flown interpretation. At most he would have said that it was his duty to satisfy his royal master with a correct record. He might have gone on to say that in his youth he had been able to paint single heads accurately enough in the Roman manner, but that they seemed to him lacking in life. Later he had learnt from the Venetians how to give to his figures the appearance of flesh and blood, but they did not seem to be surrounded by air. Finally, he had found a means of doing this too, by broader strokes of the brush, but how precisely this came about he could not tell.

This is usually the way in which good painters speak about their work. But after two centuries of aesthetic philosophy we cannot leave it at that. No reasonable person can still believe that imitation is the end of art. To do so is like saying that the writing of history consists in recording all the known facts. Every creative activity of the human race depends on selection, and selection implies both a power to perceive relationships and the existence of a pre-established pattern in the mind. Nor is this activity peculiar to the artist, scientist or historian. We measure, we match colours, we tell stories. All through the day we are committed to low-grade aesthetic activities.

Velasquez

We are being abstract artists when we arrange our hair brushes, impressionists when we are suddenly charmed by a lilac shadow, and portrait-painters when we see a revelation of character in the shape of a jaw. All these responses are wholly inexplicable and remain unrelated until a great artist unites and perpetuates them, and makes them convey his own sense of order.

With these speculations in mind I return to the *Meniñas* and it occurs to me what an extraordinarily personal selection of the facts Velasquez has made. That he has chosen to present this selection as a normal optical impression may have misled his contemporaries, but should not mislead us. There is, to begin with, the arrangement of the forms in space, that most revealing and personal expression of our sense of order; and then there is the interplay of their glances, which creates a different network of relationships. Finally there are the characters themselves. Their disposition, which seems so natural, is really very peculiar. It is true that the Infanta dominates the scene, both by her dignity—for she has already the air of one who is habitually obeyed—and by the exquisite beauty of her pale gold hair. But after looking at her, one's eye passes immediately to the square, sullen countenance of her dwarf, Maribárbola, and to her dog, brooding and detached, like some saturnine philosopher. These are in the first plane of reality. And who are in the last? The King and Queen, reduced to reflections in a shadowy mirror. To his royal master this may have seemed no more than the record of a scene which had taken his fancy. But must we suppose that Velasquez was unconscious of what he was doing when he so drastically reversed the accepted scale of values?

As I stand in the big Velasquez room of the Prado I am almost oppressed by his uncanny awareness of human character. It makes me feel like those spiritualistic mediums who complain that they are being disturbed by 'presences'. Maribárbola is such a disturbing element. While the other protagonists in the *Meniñas*, out of sheer good manners, take their parts in a sort of *tableau vivant*, she affronts the spectator like a blow from a muffled fist; and I remember

8 VELASQUEZ: The dwarfs Maribárbola and Nicolasito, from *Las Meniñas*

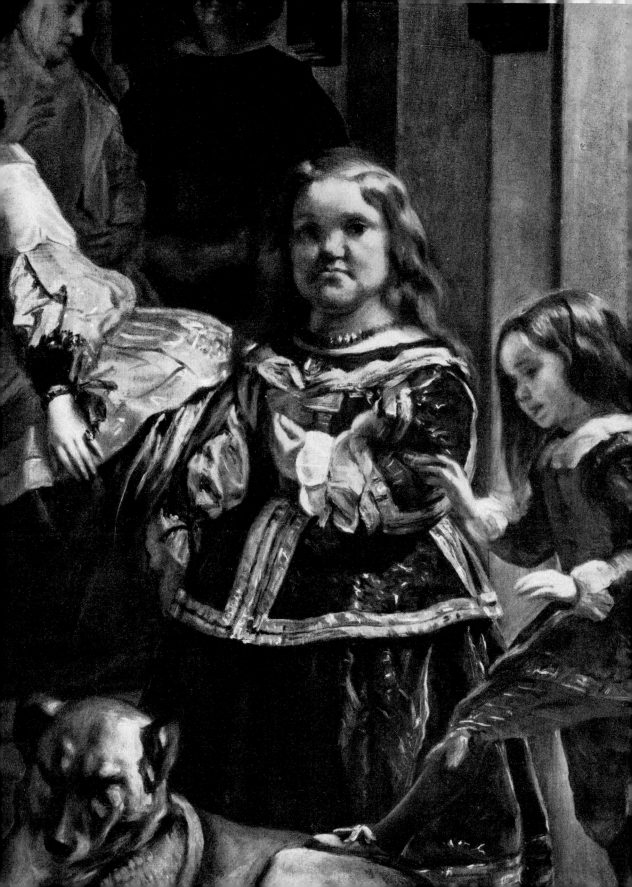

the strange and poignant relationship which Velasquez had with all the dwarfs and buffoons whom he painted. No doubt it was part of his duties to record the likenesses of these Court favourites, but in the main Velasquez room of the Prado there are as many portraits of buffoons as there are of the royal family (nine of each). Surely that goes beyond official instructions and expresses a strong personal preference. Some of his reasons may have been purely pictorial. Buffoons could be made to sit still longer than royal persons, and he could look more intensely at their heads. But was there not also the feeling that their physical humiliations gave them a reality which his royal sitters lacked? Take away the carapace of their great position, and how pink and featureless the King and Queen become, like prawns without their shells. They cannot look at us with the deep questioning gaze of Sebastián de Morra or the fierce sullen independence of Maribárbola. And I begin to reflect on what would happen to *Las Meniñas* if Maribárbola had been removed and a graceful young lady of the Court put in her place. We should still feel that we were there; the colour would be as subtle, the tone as scrupulously correct. But the temperature would have dropped: we should have lost a whole dimension of truth.

Las Meniñas (The Ladies-in-Waiting), by Diego de Silva y Velasquez (1599–1660), is in oils on canvas, measuring $123\frac{1}{4}'' \times 108\frac{1}{2}''$ (3.13 × 2.76 m.). It was painted in 1656 for Philip IV of Spain, in a room of the Alcazar Palace of Madrid. The pictures on the walls are copies by del Mazo of originals by Rubens and Jordaens. The Infanta Margarita, daughter of Philip IV and his second wife, Mariana of Austria, daughter of the Emperor Ferdinand III, herself became Empress of Austria, and two other portraits of her by Velasquez are in the Vienna gallery. The kneeling lady-in-waiting, who is offering the Infanta a little red pot of (?) chocolate, is Doña María Augustina Sarmiento; the other meniña is Doña Isabel de Velasco. The dwarfs are called Maribárbola and Nicolasito. The *duenna-gouvernante* figure, known as a *guardadamas*, is Doña Macella de Ulba. The man at the door is Don José Nieto Velasquez, thought to be a relation of the painter. Velasquez is wearing the red cross of the Order of Santiago which he did not receive till June 12, 1658. The story that the king, on seeing the picture, said 'one thing is missing' and painted on the cross himself is therefore untrue. It is skilfully painted, and must have been added either by Velasquez himself or by del Mazo.

The *Meniñas* is mentioned in the 1666 inventory of the Alcazar. It was saved from the fire of 1734 and placed in the new palace, where it was known as *La Familia*. It was transferred to the Prado when the gallery was opened in 1819, and is first referred to as *Las Meniñas* in the 1843 catalogue of Pedro Madrazo.

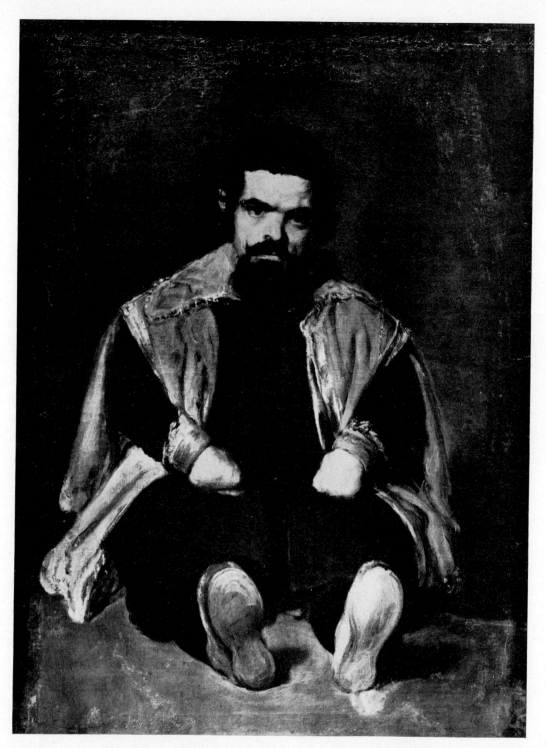

9 VELASQUEZ: *The Dwarf Don Sebastián de Morra*. Madrid, Prado

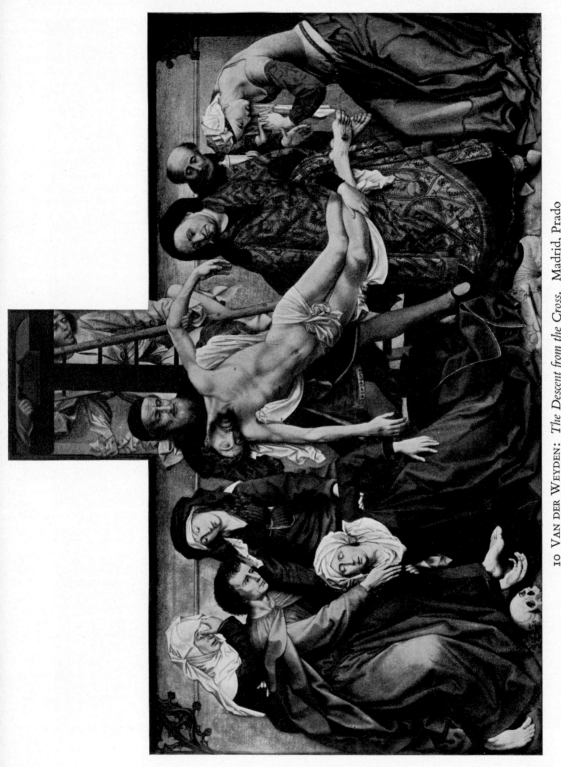

10 VAN DER WEYDEN: *The Descent from the Cross.* Madrid, Prado

ROGIER VAN DER WEYDEN

The Descent from the Cross

I<small>T IS</small> a double-distilled work of art. The figures seem to have become art before they were painted. They remind me immediately of polychrome sculpture, and I remember that Rogier himself, at the height of his fame, was not above colouring sculpture, just as Zeuxis had coloured the sculpture of Praxiteles. Not only are the figures arranged as if in high relief before a plain gold background; they have the formal perfection of a classical frieze and hold their positions in the design with no feeling of weight or possible fatigue. And yet the noble artifice of the whole is combined with an almost shocking realism in the parts. My eye is immediately drawn to these details and for some minutes I can think of nothing but the stereoscopic intensity with which they are seen and the microscopic precision with which they are rendered.

The combination is, and always has been, irresistible: 'I say that learned and unlearned alike will praise those heads which appear to stand out from the picture as if they were sculptured'. Those words, from Alberti's treatise on the art of painting, were probably written in the very year that Rogier painted his *Descent from the Cross*. They were true in 1435 and remained true till the time of Roger Fry: for what other meaning can one give to the words 'plastic values' which echo through his writings. Alberti does not say 'as if they were real' but 'as if they were sculpture', implying thereby a purposeful simplification of each form intended to make it more vividly experienced by the spectator; and this Rogier has achieved in the highest degree. The Virgin's head is surely one of the greatest examples of 'tactile

values' in painting. It also illustrates Winckelmann's classic definition of art as 'Unity in Variety'. It looks austerely simple, and the eyes, nose and mouth have a consistency of form which is more usually found in abstract art; but if I compare this densely modelled oval with such a stylised object as an African mask, I marvel at the accuracy of Rogier's observation. Not an atom of truth has been sacrificed and every detail has a double significance. The tears which trickle down the Virgin's face enhance by their movement our sense of its modelling. The unyielding will-power behind each stroke is almost that of an engraver, but as one follows it one sees that it is the result of moral, not mechanical, certainty. It bears out that difficult sentence in Blake's *Descriptive Catalogue*: 'What is it that distinguishes honesty from knavery but the hard and wiry line of rectitude and certainty in actions and intentions?'

The little we know about Rogier van der Weyden's life suggests that he was a man of admirable rectitude. He was born in Tournai in 1399, the son of a master cutler; and in 1427, although already an established painter, he was apprenticed to a Tournai master with a high reputation named Robert Campin. The documents which can be related to these early years are even more confusing than usual, but I think it almost certain that Campin was the painter known as the Master of Flemalle, whose strong sculptural style is so apparent in Rogier's early work that historians have tried (unconvincingly) to prove that he and Rogier are the same man.

Rogier's apprenticeship ended in 1432 and by 1435 he had already invested a large sum of money in Tournai securities, perhaps as a result of painting the *Descent from the Cross*. A year later he was given the life appointment of Painter to the City of Brussels. He became internationally famous. The princely connoisseurs of Italy wrote to him in flattering terms, and he visited Rome, Florence and Ferrara. But the greater part of his life was spent in serious thought and scrupulous industry. Large and small commissions were executed with equal care, and when in the 1450's taste inclined towards a more

11 VAN DER WEYDEN: The Virgin Mary, from *The Descent*

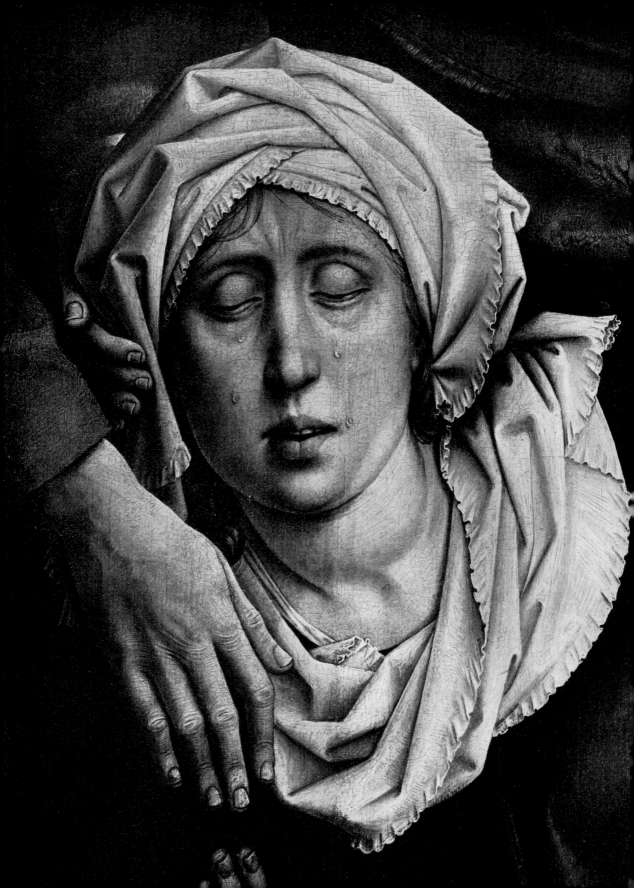

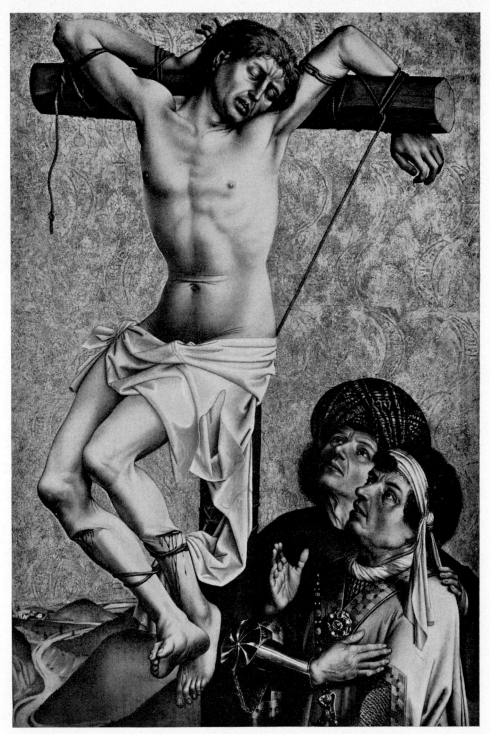

12 MASTER OF FLEMALLE: The unrepentant thief, from the Flemalle Altarpiece.
Frankfurt, Städelsche Kunstinstitut

brilliant and jewelled style, he was prepared to meet it. Then, at the end of his life, he executed as a gift to the monastery of Scheut the *Crucifixion* now in the Escorial, before which we think of Dante and the late drawings of Michelangelo. Rhetoric, decoration, brilliance of colour, sharpness of eye, all earthly accomplishments have been whittled away. It is perhaps the most self-possessed and serious picture ever painted north of the Alps.

With the thought of his grave and awe-inspiring character in my mind I now turn back to the *Descent from the Cross*. It was commissioned by the guild of archers for their chapel in the Church of Notre-Dame-hors-des-Murs at Louvain. We do not know when it was painted, but personally I have little doubt that it is the first great painting which Rogier executed after leaving his master, and it recalls the work of Campin at many points. There is the same bare concentration on form that one sees in the fragment of the Flemalle Altarpiece, the same intense application to the facts and even some similar types of head and hand. Although Rogier van der Weyden was to be a great inventor of pictorial motives, Campin gave him his direction. In these years Jan van Eyck was exploring depth with an uncanny perception of light and atmosphere. Campin, on the other hand, had a passion for hard substances—oak benches, dinanderie sconces, pewter pots—and in the formation of his style must have received a powerful impulse from the realistic sculpture of Burgundy, then only thirty years old, with its colour still bright. This love of tangible facts, as opposed to optical adventures, Campin transmitted to his pupil. But Rogier had to a far greater degree the faculty of idealisation. He is, in the full critical sense of that term, a classic artist. He concentrates on man, not man as a continuation of Nature, but man as the unique and isolated creation of God. He looks in the diversity of mankind for certain dominant characteristics, each of which shall be expressive of some activity of the human spirit. And these essences of humanity are shown to be deeply involved with one another, but involved according to certain principles of fate or

47

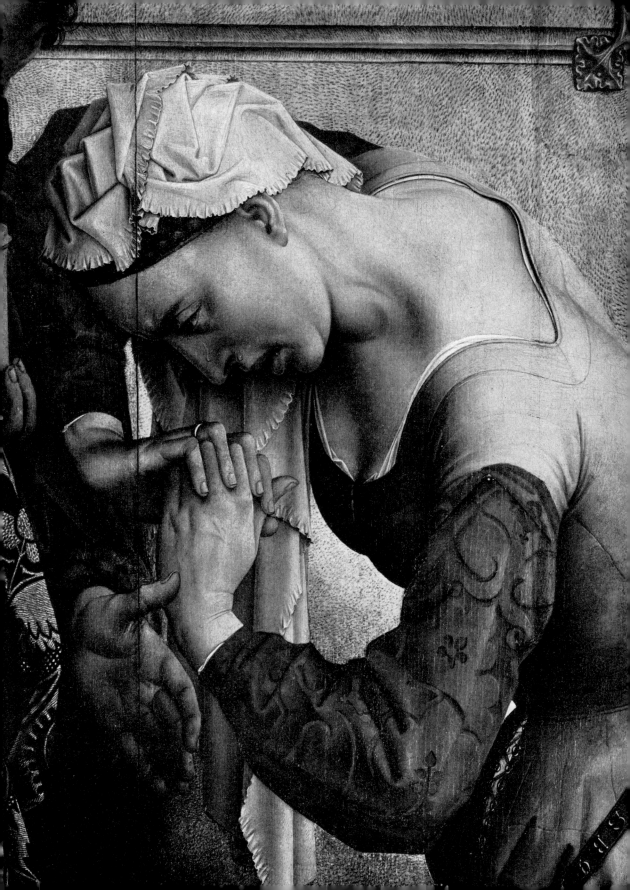

The Descent from the Cross

design. It is a Sophoclean conception of drama which is presented to us on the narrow stage of the *Descent from the Cross*.

The main lines of the composition are very simple, an oblong rectangle of upright figures enclosed, as it were, by two curved brackets. Within this rectangle the forms circulate, not smoothly, but painfully, their rhythm being in each case broken by the awkward line of a bent elbow—first the elbow of Christ's left arm, then the more sharply angular elbow of the Virgin, and finally the Magdalen, whose twisted pose is the point of greatest tension in the whole design. At the centre of the drama the figure of Christ seems to float without weight, like a crescent moon. In the fragile, tranquil beauty of His body I feel the difference between Rogier and his master; for Campin, to judge by the Flemalle thief, had an almost Ferrarese love of knobs and twisted knuckles. And with these Italian analogies in mind I reflect on the similarity of mood between our picture and the *Descent from the Cross* by Fra Angelico, probably painted in the same decade. There is in both a slow tempo of resignation, an absence of strain and passion, which would be frustrating did we not feel that both painters were men of deep piety, for whom the Passion of Our Lord was the central fact of existence.

Apparently Rogier was conscious of some kinship with the saintly Florentine, for in his *Entombment*, now in the Uffizi, the chief motive of the composition is derived from a picture of the same subject in the predella of Angelico's S. Marco altarpiece. Yet as soon as I think of Angelico I realise how profoundly un-Italian Rogier remained. His use of paint is based on the brilliant craftsmanship of the northern scriptoria, whereas Italian colour of the same date is still connected with the loose, opaque touches of fresco painting. In our picture the strong contrasting blue and red of the Virgin and St John would have seemed commonplace to Fra Filippo or Uccello, although they might have observed that the lavender and sedge-green dress of the Magdalen, setting off her scarlet sleeves, is a colour scheme worthy of their own Gentile da Fabriano (the other Italian painter, incidentally, whom

49

Rogier Van Der Weyden

Rogier is known to have admired). The heraldic simplicity of
Rogier's reds and blues was, of course, part of the tradition of symbolic
colour going back to the master glass-painters of the middle ages,
and it is this, quite as much as technical skill, which makes it so brilliant.
When Florentines like Ghirlandajo imitated the brilliance, without the
traditional knowledge, the result was garish. Equally far from his
great Italian contemporaries is the restless articulation of Rogier's
draperies. Never for a second is the eye allowed an uninterrupted
joy-ride, nor encouraged to rest on a comprehensible volume with
the pleasant feeling that it knows what is on the other side. The sense
of strain which is repressed in the heads shows itself in the clashes and
struggles of the drapery.

Nevertheless it is to the heads that I return: the heads, hands and
feet. Rogier has achieved that difficult aim, an idealisation that does not
destroy identity. Here again he continued the great tradition of Gothic
art, for it is in the kings and saints of Chartres and Amiens that this
fusion of individual character and universality reaches its peak. The
Italians, after Masaccio and Donatello, never quite achieved it. Alberti
warned the painter that a realistic portrait would always draw the eye
away from idealised heads, even if they were 'more perfect and
pleasing'; and for this reason the Italians of the high Renaissance did
their best to avoid them. They were, moreover, so deeply impressed by
the smooth mould of Greco-Roman sculpture that they could scarcely
admit a wrinkle, still less the stout, unshaven jowl of the Nicodemus
in Rogier's picture, who almost illustrates Alberti's warning. Even
supposing that he represents some individual, he has somehow been
brought into the classic drama, and is no longer a portrait. Thus
my eye returns to the Virgin's head, and I observe how her linen
head-dress has the same kind of circular movement as the Magdalen's
arms, breaking and starting without loss of momentum in what
Gerard Manley Hopkins called 'sprung rhythm'. Finally I look down
at her hands. They are not only beautiful in themselves, but each has a
sympathetic relationship with another member. Her left hand, inert

14 VAN DER WEYDEN: Hands of Christ and the Virgin, from *The Descent*

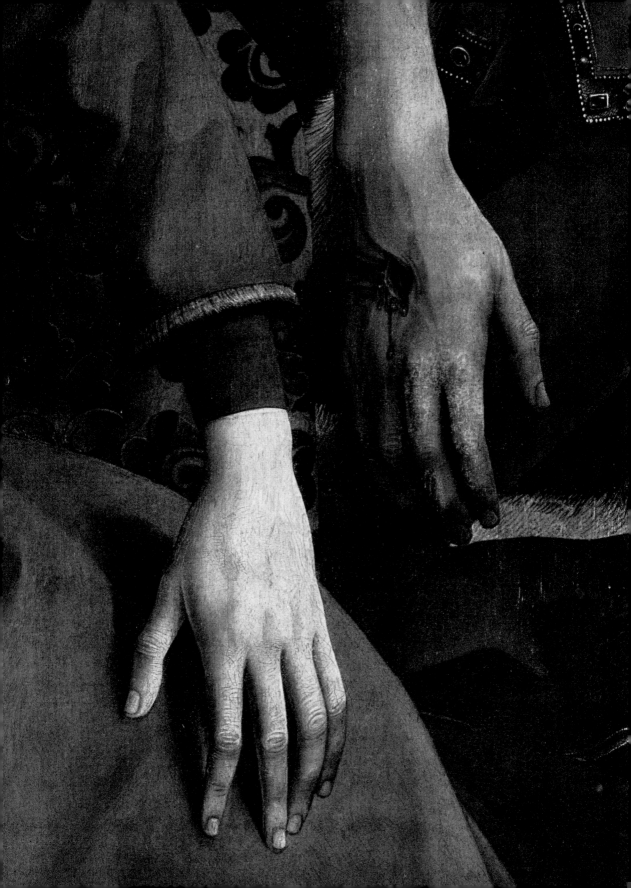

but still living, accompanies the lifeless hand of Christ, her right hand, between a skull and St John's exquisite foot, seems to draw some new life from the earth. I then follow the ascending diagonal of her drapery and St John's arm till my eye rests on his head. He is a type which is to reappear in Flemish art for the rest of the century and to a large extent he is Rogier's creation. Leonardo da Vinci maintained that in such figures the painter could not avoid reproducing some reflection of his own features, and in fact a portrait drawing of Rogier in the Arras sketch-book shows just such a convinced, earnest and ascetic character. He is not a companion for our moments of relaxation, nor does he flatter us with the prospect of an unattainable ideal. No ecstasy; only the common task. He is St Bourgeois, the God-fearing man of an industrious society, accepting the reality of material things, holding them in useful readiness by his will and knowing that in the end they must be transcended.

The Descent from the Cross, by Rogier de la Pasture, called Rogier van der Weyden (c. 1400–1464), is painted in a mixed medium of tempera and oil on wood, measuring $86\frac{1}{2}'' \times 103''$ (2.20 × 2.62 m.). It was commissioned by the guild of archers of Louvain for the Church of Notre-Dame-hors-des-Murs in that city. It was purchased from them by Maria of Hungary, wife of Charles V, and sent to Spain. It entered the Escorial in 1547 and remained there till 1945, when it was sent to the Prado on the instructions of General Franco. The date of the picture is much debated. Owing to the fact that the Nicodemus resembles a portrait by Campin thought to represent Robert de Masmimes, who died in 1430, certain authorities date it in that year. Recent writers put it as late as 1443. The date of 1435 is suggested both by the style and by the fact that in this year Rogier acquired wealth and fame, and this turning-point in his career could have been the result of painting this masterpiece.

 The Descent from the Cross was recognised as a masterpiece from the first. It was copied in 1443; and in 1569 Philip II commissioned the excellent copy by Coxcie which used to hang in the Prado and has now taken the place of the original in the Escorial.

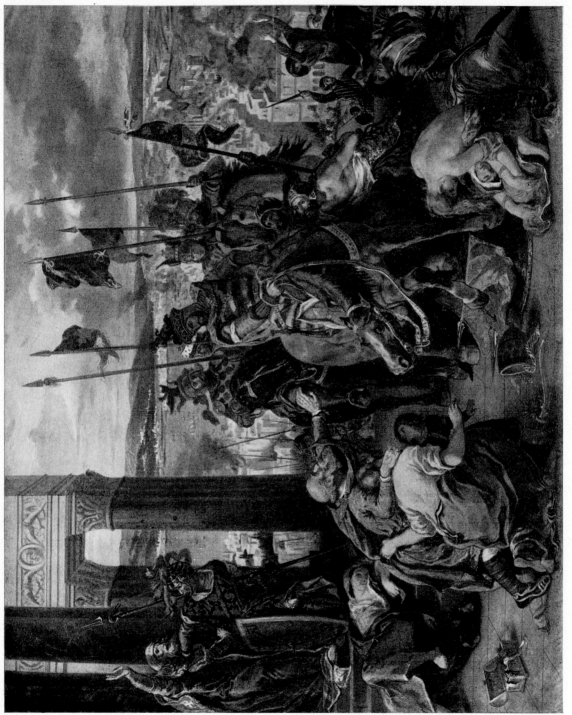

15 DELACROIX: *The Crusaders Entering Constantinople.* Paris, Louvre

DELACROIX

The Crusaders Entering Constantinople

A QUANTITY of hostile instincts must be overcome. There is its size and its theatricality, and the memory of illustrations to Walter Scott and all the boring flummery. of nineteenth-century romanticism; and, to be more serious, there is a kind of restlessness, so that the eye can never settle down and enjoy that feeling of sensuous peace which it derives from one area of tone being comfortably related to another. To look carefully at the great works of Delacroix in the Louvre requires an effort of will, and I sympathise with the exhausted visitors who stagger on to Vermeer's *Lace-Maker*. But if I pause for two minutes before this vast, smoky canvas and its flamboyant neighbour, *The Death of Sardanapalus*, I gradually become aware that I am encountering one of the great poets of the nineteenth century and one who expressed himself, with absolute mastery, through colour and line.

Of course, my judgement is to some extent swayed by my reading. Delacroix aroused in Baudelaire the same all-consuming, uncritical passion that Turner aroused in Ruskin, and from these two eloquent admirations were written some of the few pages of art criticism which can still be read as literature. Moreover, Delacroix was himself a brilliant writer and the finest expositor of his art since Leonardo. His journals expose to us a character as alive and intelligent as the hero of a novel by Stendhal. It is possible that I might never have loved his paintings so much (and I confess that I have an almost Baudelairean appetite for them) had I not first been captivated by the quality of his mind; and, in fairness to the reader, I will therefore say something

about his life before looking more attentively at the *Crusaders*.

He was born in 1798, and was probably the son of Talleyrand, to whom, in later life, he came to have a close physical resemblance. His self-portrait in the Louvre was painted at the age of thirty-seven, and although, like most self-portraits, it presents the sitter at his most amiable, one can detect something of the energy, the will and the disdain which were scarcely concealed under the elegant exterior of a man of the world. One can see that look of the wild animal which struck all his contemporaries, in the powerful jaw and narrowed eyes.

'Le tigre, attentif à sa proie, a moins de lumière dans les yeux et de frémissement impatient dans les muscles que ne laissait voir notre grand peintre quand toute son âme était dardée sur une idée ou voulait s'emparer d'un rêve.'

The tiger. That word comes early in every study of Delacroix, and with justification. Nearly all his great works involve the shedding of blood, many of them are scenes of indescribable carnage. At feeding-time in the Paris Zoo, an event which he seldom missed, he was, he tells us, 'pénétré de bonheur'.

But there was another side to his nature which gave the tiger its value. He was a highly developed example of what Spengler called Faustian man—more so, perhaps, than the author of Faust, who, incidentally, found that the Delacroix illustrations to his dramatic poem had 'greatly enlarged its meaning'. One of Delacroix's earliest paintings shows him in the costume of Hamlet, not certainly the irresolute princeling, but the young scholar, overburdened with intelligence. Delacroix grew less like Hamlet as he grew older, as I suppose Hamlet would have done. His unanswered questions settled into a *fond* of stoicism. He remained the glass of fashion out of an ironical contempt for the usages of Society. He was, in Baudelaire's sense of the word, the highest embodiment of the Dandy. But when he took off his clothes in the English cut, which he was one of the first to introduce into Paris, and put on the costume of an Arab, we can see how this great pessimist was withdrawn from the world, above all

II DELACROIX: Dying woman. Detail from *The Crusaders*

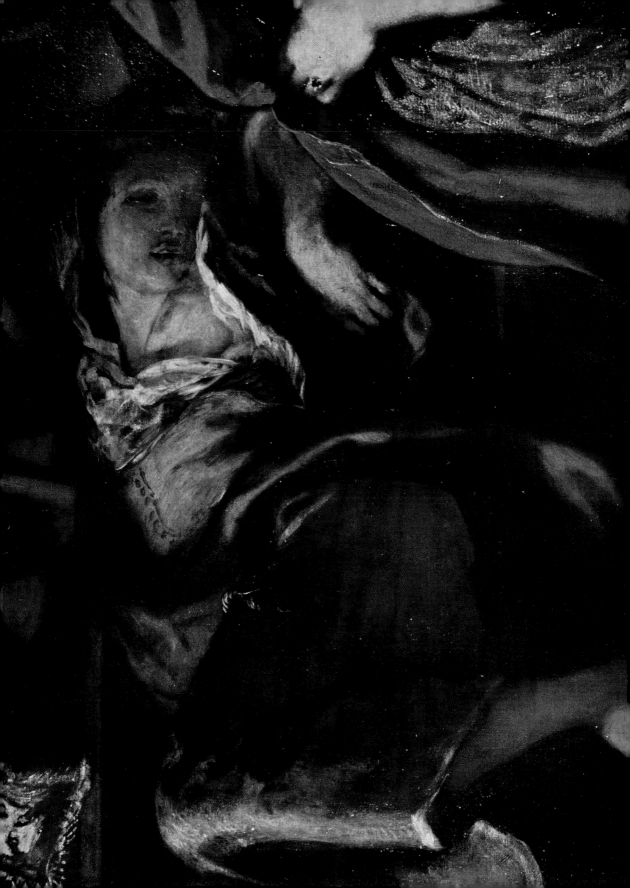

from the prosperous, crassly hopeful world of the nineteenth century. Like Jacob Burckhardt, almost the only thing which irritated him into open contempt was talk about progress. He knew that we had just survived by the skin of our teeth, and he saw no convincing reason why we should do so again.

He used to describe the three great canvases which he painted before 1840 as his 'three massacres', and it is true that they show the continuity of his interest in violence; but they also illustrate the development of his mind. The first, *The Massacre of Chios* (1824), is one of those rare pictures which still have power to move us although painted, like Picasso's *Guernica*, as the result of an immediate event; and one can imagine what it must have meant to a young man of the time, when one remembers that it was exhibited in the same salon as Ingres' most boring success, *The Vow of Louis XIII*. Delacroix's indignation and hatred of tyranny were sincere, but they were to some extent conventional, and his second massacre, *The Death of Sardanapalus* (1827), is more personal. Baudelaire said, 'It was the savage part of his soul which was entirely dedicated to the painting of his dreams'. But here, too, the dream was not entirely his own, since an image of carnal frenzy, culminating in violent and voluntary death, has been part of the romantic myth from the Marquis de Sade to Axël.

His third massacre, *The Entry of the Crusaders into Constantinople*, could have been imagined by no one else. Ten years have passed since *Sardanapalus* and Delacroix's views on human destiny have changed considerably. He has been to Morocco and found there, not the sensual ferocity of his dreams, but an ancient and dignified way of life which he at once recognised as far more classical than the wax-work classicism of the salon. He has become intimate with the finest spirits of his time, Alfred de Musset, George Sand and his beloved Chopin, whose music was to him 'like a bird of brilliant plumage fluttering over the abyss'. And he has evolved a philosophy of history strangely similar to that of Nietszche and Burckhardt. Of this the greatest illustration is contained in the library of the Chambre des Députés which he

Delacroix

decorated between 1838 and 1845. The most complete and the most accessible is the *Crusaders*.

Thiers had commissioned it for Versailles, to hang with the colossal canvases of Baron Gros and Horace Vernet, representing the Victories of Napoleon, and nobody seems to have detected any irony in his choice of subject, although Delacroix has made his intentions perfectly clear. He tells us that he always took pains that his pictures should express their meaning by their general tone and colour, and work upon the mind long before one could read their content. The colour of the *Crusaders* is grave and sombre. The sky is darkened by the smoke of the burning city and the group of crusaders, in the shadow of a cloud or of smoke, seems to be a mass of purple and violet. The only relief to the eye is the light blue of the Bosphorus, with a few red sails, like bugle calls from the distant conflict.

The *Crusaders* differs from the other massacres in that Delacroix no longer derives any pleasure from violence. He has lost confidence in the barbarians. In most of his 'skin of our teeth' pictures one feels that the life-force of the destroyer is, in many ways, more valuable than the detritus of a worked-out civilisation, but here the conquerors are themselves exhausted. No longer buoyed up by the blind energy of Attila in the Députés, they look on their victims with sorrow and perplexity. Having conquered the civilised world, they have no idea what to do with it. They will destroy it out of sheer embarrassment.

"But you have been praising it as literature", the reader may say; "what can be said for it as painting?" It is not a question which would be asked in France; but Delacroix's admiration for the country of Shakespeare, Byron and Scott has not been reciprocated. A Parisian hostess, seeing her favourite guest slip away from a party, is reported to have said: "What a charming man M. Delacroix is; what a pity it is that he paints." That has been the English attitude, and there are so few of his pictures in this country that I do not suppose it can be changed. Moreover, since they depend for their effect on colour rather than tone, his pictures photograph badly. Even his enemies recognised

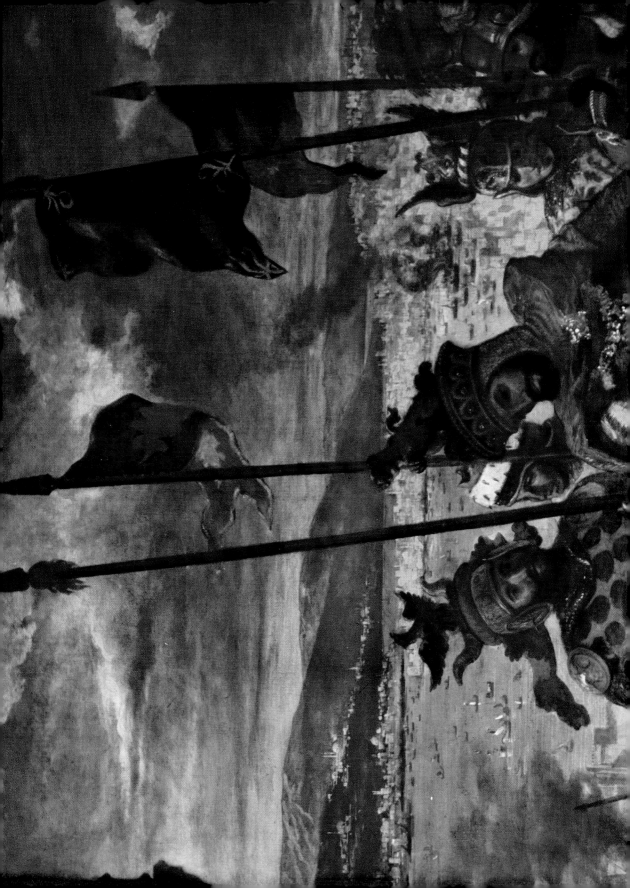

that he was a great and profoundly original colourist, obtaining certain effects by the juxtaposition of complementaries which were ultimately to lead to the discoveries of Seurat. His colour is sometimes misjudged by those who expect it to be either like that of Rubens or the Venetians. Rubens and Titian were, of course, his masters, but his intention is entirely different. He does not build up harmonies for their own sakes, but uses colour as a means of dramatic expression; and as most of his themes are tragic or terrifying, his colour is often sinister. He liked to bring together the livid blues and purples of menacing skies. He was particularly fond of a nightmarish bottle-green, which alarms us because it is the complementary of blood red; and this no doubt was in Baudelaire's mind when he wrote in *Les Phares*: 'Delacroix, lac du sang hanté des mauvaises anges, Ombragé par un bois de sapins toujours verts'. All this is lost in a photograph, and the same is true of his expressive handling of paint. Delacroix had a vigorous and characteristic 'hand-writing' which is perceptible in every stroke of his brush, but disappears in reduction. I love to look at a Delacroix very closely, enjoying the savage energy with which he applies even quite amiable colours. But in the *Crusaders* I cannot peer at anything higher than the horse's neck, and so can sympathise with those amateurs who take pleasure in his small pictures or sketches, while still resisting the great machines.

Delacroix himself recognised the superior vividness of his sketches; but he wrote: 'Il faut toujours gâter un peu un tableau pour le finir'. He took immense pains to keep the surface of his pictures alive, and if it were possible to cut out and exhibit separately details of the *Crusaders*—the dying woman to the left, for example, or any part of the stupendous landscape—they would be much admired. One such detail is frequently abstracted from the whole composition: the half-naked woman bending over her companion in the right foreground. She is that familiar romantic symbol, the flower beneath the foot, and it is not surprising that the great romantic artists have looked on her with gratitude. Her hair and back, like water flowing over a stone or

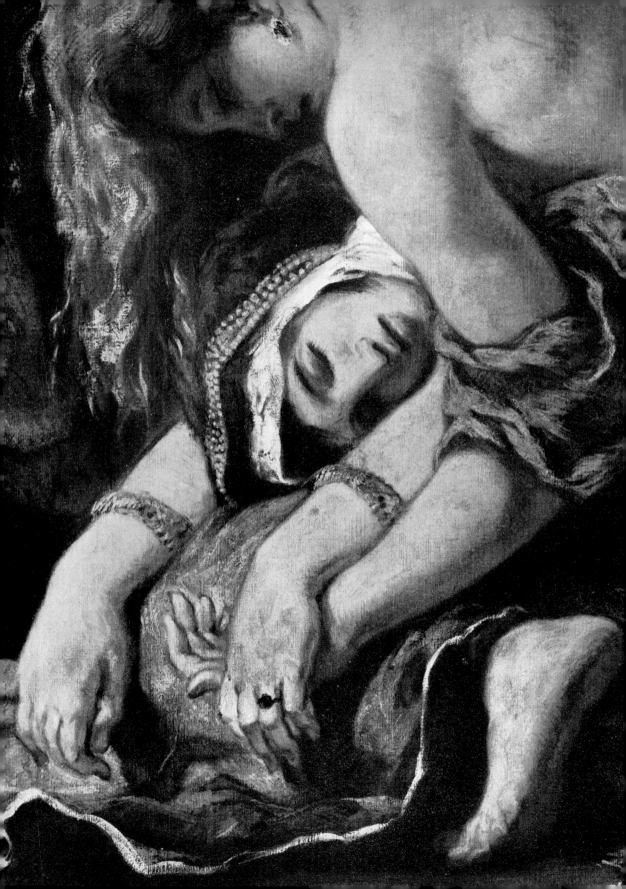

a breaking wave, inspired the *Danaïd* of Rodin, and her companion's inverted face seems to have been the starting-point for a whole series of drawings by Picasso.

That the *Crusaders* is, in the best sense of the word, theatrical it would be foolish to deny. This charge was made when it was first exhibited, and met by Baudelaire with the admirable phrase 'la vérité emphatique du geste dans les grandes circonstances de la vie'. True enough; but we must admit that in no circumstances would the two women have adopted such eloquent poses before the advancing cavalcade, and Delacroix does not really ask us to believe that they did. His conviction was of a different kind: that art must re-create events in the light of the imagination, so that they assume the quality of poetry. He was perhaps the last European painter successfully to follow the advice of Horace which had led so many second-rate artists astray, *ut pictura poesis*. We can criticise the *Crusaders* only as a form of poetic drama and those of us who do not care for the classic style of acting, the style of Kean and Chaliapine, may resist the emphatic gestures of the two aged Byzantines. But surely no one can look unmoved at the crusaders themselves, that bewildered group, caught in the melancholy vortex of their horses' necks, their banners and fantastic helmets silhouetted, like puppets in some Tibetan ritual, against the expiring capital of the ancient world.

The Crusaders Entering Constantinople 1204, by Eugenè Delacroix (1798–1863), is in oil on canvas, measuring $161\frac{1}{2}''\times196\frac{1}{4}''$ (4.10 × 4.98 m.). It was commissioned for Versailles in 1838, and is signed and dated 1840. It was transferred to the Louvre in 1885. There is a small-scale variant painted by Delacroix dated 1852, which passed to the Louvre from the Moreau collection.

16 DELACROIX: Two women. Detail from *The Crusaders*

17 RAPHAEL: *The Miraculous Draught of Fishes.* London, Victoria and Albert Museum

RAPHAEL

The Miraculous Draught of Fishes

To ENTER the hall in the Victoria and Albert Museum which contains the Raphael cartoons (and which, incidentally, is almost exactly the same size as the Sistine Chapel, for which they were designed) is to aspire to a higher order of being. It can begin badly. We are not always calm enough or strong enough to make the effort. We require images closer to the contemporary excitements we have left outside; and so we sit there in a state of respectful boredom, looking from one to another of these great, glazed rectangles, waiting for something to happen.

It happens when our eyes have rested for a few minutes on *The Miraculous Draught of Fishes*. This may not be the grandest of the cartoons, but it is the most accessible, and provides, as a bonus, those qualities of light and colour to which our recent pictorial experiences have made us responsive. There are fish that might be by Turner, reflections in the water which could come from Cézanne. Our eye is engaged, our capacities begin to gain in strength and fullness, and before we know where we are we have begun to participate in the strenuous life of the Grand Manner.

It is a world as far from actual experience as the language and images of Milton are far from every-day speech. Whatever the original episode in St Luke's Gospel was like, it was not like this, and Raphael never supposed that it was. But he was treating a great theme, and decorating the most splendid room in Christendom, and in consequence every figure and every incident must be made as noble as the story would allow. What did he mean by that word? Looking at the

Raphael

Miraculous Draught, I see that the figures are robust and handsome specimens of humanity. They represent a golden mean of biological success, which excludes equally the rough and the weak, the boisterously animal and the over-refined. They have no hesitations, nor secret thoughts, but stand up in the open and concentrate whole-heartedly on what they are doing. But this condition of being is achieved through style. Just as Miltonic diction could raise almost every episode to a certain level of nobility, so Raphael's power of finding a simple, comprehensible and well-shaped equivalent for everything he saw gives an elevated unity to the whole scene.

Without this unity of style I should be disturbed by the fact that the two groups are conceived in different moods. The group in the right-hand boat represents art for art's sake. During the first twenty years of the sixteenth century, a foreshortened nude figure and, in particular, a foreshortened shoulder were thought to be the most gratifying form on which the eye could rest, and in the two sons of Zebedee bending over their nets, Raphael is consciously giving a proof of his mastery of *disegno*, that key word of the Renaissance which meant drawing, design and formal conviction all in one. Zebedee himself, seated in the stern, is intended to recall an antique river god, and the whole splendid boatful is addressed to the connoisseur, whom it cannot fail to please as long as there survives any memory of the classic tradition.

The group in the left-hand boat, on the other hand, is addressed to the believer. "Depart from me; for I am a sinful man, O Lord." By this profoundly human response to a piece of miraculous good fortune Raphael's imagination has been touched and quickened so that style no longer dominates truth.

But in trying to examine the groups separately I begin to realise how closely they are dependent on one another. A rhythmic cadence runs through the whole composition, rising and falling, held back and released, like a perfectly constructed Handelian melody. If we follow it from right to left (and as this is a tapestry design it will ultimately

18 RAPHAEL: James and John and Zebedee, from *The Miraculous Draught*

be seen in reverse) we see how the 'river god', like a stoker, drives us into the group of heroic fishermen and how the rich, involved movement of this group winds up a coil of energy; then comes an artful link with the standing Apostle, whose left hand is backed by the fisherman's billowing drapery, and then St Andrew himself forming a *caesura*, a climax in the line, which holds us back, without lessening our momentum. Then, at last, the marvellous acceleration, the praying St Peter to whose passionate movement all these devices have been a preparation, and finally the comforting figure of Christ, whose hand both checks and accepts St Peter's emotion.

In course of this analysis I gradually notice subtleties of design which the firmness of Raphael's style at first conceals: for example, the way in which St Peter's arms pass into shadow, but his praying hands emerge into light, making him seem to leap forward towards Jesus. I also come to realise (as in an analysis of Milton) that certain passages which seemed to have only a rhetorical justification are meant to be taken literally: for example, the billowing drapery behind St Andrew's hand is moved by the same wind which blows his hair and controls the movement of the birds. Raphael's formal language is still far from the decorative eloquence of the Baroque.

By this time my mind is attuned to the grand manner, and I have no difficulty in participating in the great events depicted in the other cartoons. My eye strays to the figure of the dying Ananias in the adjacent frame and for a second I wonder how Raphael came to invent a form so complex and expressive that Michelangelo could adapt but not surpass it in his *Conversion of St Paul*. With no less astonishment I look at the beggar's head in the scene of St Peter healing cripples in the Temple, for there Raphael equals Leonardo da Vinci in the idealisation of ugliness. And in the middle of the same cartoon is a figure of archetypal Tuscan austerity, St Peter, who seems to come direct from the frescoes of Giotto and Masaccio, and yet is at home among the Syrian corkscrew pillars of the Temple gate.

As always when looking at the mature Raphael I am led to reflect

upon his unrivalled powers of assimilation. His genius is strangely unlike that of any other artist of similar stature. Titian, Rembrandt, Velasquez, Michelangelo are all essentially themselves from their first recognisable works. Their working lives are an attempt to develop and enrich this central core of their character, and they accept the influence of other artists only in so far as it corroborates their own convictions. With Raphael each new influence is decisive. That the painter of pseudo-Peruginos should, in ten years, have become the painter of the Heliodorus, seems not so much a development as a complete transformation. We have the feeling that each of Raphael's successive stylistic encounters—with Leonardo and Fra Bartolommeo, with Michelangelo, with the *Ariadne* of the Vatican and the Trajan column—leads to the discovery of something fresh and unexpected in himself.

But the most crucial of all these changes of personality resulted from a change of technique. As long as Raphael used oil paints on panel his sensitive feeling for material led him to emulate the detail and polish of Flemish art, then much esteemed in Italy and, particularly, in his native city of Urbino. But the grand manner is rooted in the Italian tradition of mural painting, and from the moment that Raphael had to cover with fresco the great spaces of the Vatican, the whole nature of his genius seemed to expand. Not only did he become technically more resourceful but his mind revealed an entirely unexpected range. Thus came into being the style which dominated academic art in Western Europe till the nineteenth century.

By an extraordinary piece of good fortune for posterity Raphael accepted the one commission which allowed him to achieve the effects of fresco painting in portable form: a series of full-sized designs for tapestries which were to be woven on the Brussels looms, and hung in the Sistine Chapel. In 1515, when the first payment was made, he had completed the decoration of the Stanza di Eliodoro and was overwhelmed with work of all kinds, and he might well have felt that designs for tapestry did not require more than preliminary drawings,

to be enlarged and executed by his pupils. But he was at the height of his powers, the subject caught his imagination and, although he certainly made use of assistants, the cartoons were substantially his own creation. The kind of water-colour in which they are executed admits of the same breadth and freedom as fresco, and in many parts of the cartoons one comes on passages executed with a certainty, a nobility of touch and a truth of tone to which the frescoes in the Vatican offer the only parallel.

The next piece of good fortune is that they survived. This is really a miracle. Almost all the great cartoons of the Renaissance have been lost, including such famous works as Michelangelo's *Bathers*. Raphael's cartoons were used continually by the tapestry-workers of Brussels for over a century. After they had been bought by Charles I they were once more in use at the Mortlake factory for another sixty years. Only in the eighteenth century were they treated as museum pieces, and even then they were moved at least five times before 1865, when the Prince Consort persuaded Queen Victoria to lend them to the South Kensington Museum 'in order to illustrate the purest and the noblest genius of whom the history of mankind can boast'. Of course they have lost some brilliancy of colour. They must have been almost as bright as those pieces of pottery by Niccolo Pelipario, where the glaze of majolica has preserved Raphaelesque tonality undimmed. And some of the colours have actually changed, as we know from the curious fact that the reflection in the water of Christ's white robe is red. The robe was originally red, and we can see it reproduced as such in the earliest tapestries. Zebedee's drapery has also faded from crimson to the white underpainting, and the disappearance of these two strong, warm notes at either end of the composition has considerably altered its character. The harmony of cool colours, white, blue, aquamarine, has particular charm to the modern eye. But it is a silver age harmony, and the resonance of Raphael's golden age has been lost.

Those who pay frequent visits to the Cartoon Gallery (and a single visit is wholly inadequate) will find themselves moved by different

Raphael

works on different days, depending on the light and on their own state of mind. Sometimes one is overwhelmed by the authority of St Paul preaching, where the architectural setting, both complex and severe, seems to symbolise the logic of his arguments; sometimes one is persuaded by the classical perfection of Christ's charge to Peter; sometimes one's attention is absorbed by details like the poetic figure of St John distributing alms in *The Death of Ananias*. But in the end one returns to *The Miraculous Draught of Fishes* as being the most personal of the whole series. It is pure Raphael. The places in his work where he has assimilated the discoveries of Masaccio and Michelangelo may fill us with admiration and astonishment, but we really warm to him in front of those figures which seem to come direct from the *primum mobile* of his art. Such, in my experience, are the Muses in the *Parnassus*, the young men surrounding Pythagoras in the School of Athens (but that is all pure gold), and the astonished congregation which witnesses the miracle at Bolsena. In these we find two of his chief characteristics, a flow of movement and a nourishing sense of fullness in every form.

The effect of movement in painting is most easily achieved by line; only the greatest artists can unite it with a feeling of substance. Raphael had from his earliest youth an instinctive sense of volume which, as he grew older, was united with a noble sensuality. He did not at all despise, like later academics, the pleasure of the eye, and the pink and grey cranes in the foreground of the *Miraculous Draught* are as visually exciting as a *gitane* by Manet. But when he came to the human body he wanted to grasp it, and he is able to make us feel that we can grasp the hands and limbs of his Apostles.

How, then, could these solid bodies be given the appearance of movement? That was the lesson which Raphael learnt first from the Florentines and finally from classical antiquity. It involved knowing which poses imply a continuum of movement throughout the whole body and seem to transmit some of their momentum to the adjacent figures. It involved a perfect adjustment of balance and strain. Of this

70

20 RAPHAEL: Head of St Peter, from *The Miraculous Draught*

Raphael

St Peter and St Andrew in the *Miraculous Draught* are splendid examples. But in addition to this mastery of means, the movement of Raphael's figures has a quality which cannot be learnt, that inner harmony which we call grace; and as that word spreads ripples of memory through my mind, I look again at the Cartoons, with fresh delight and fuller understanding.

The Miraculous Draught of Fishes, by Raphael (1483–1520), is painted in sized water-colours on numerous pieces of paper glued together, the whole measuring $125\frac{1}{2}'' \times 157''$ (3.188 \times 4.0 m.). It is one of a set of ten cartoons for tapestries commissioned by Leo X in 1515. They were to hang below the windows in the Sistine Chapel, a part of the wall occupied, then as now, by painted draperies. The cartoons were completed by the end of 1516 and sent to Brussels to be woven. The weaver in charge was Pieter van Aelst. He worked rapidly in low warp weaving, and seven of the tapestries were hung in the Chapel on Christmas Day 1519. The cartoons, with one exception, remained in Brussels; tapestries were woven from them for Francis I and Henry VIII, and they continued to provide models till about 1620. Some time after 1623 seven of them were purchased by Charles I to be used in the newly established Mortlake tapestry works, and a number of sets were woven. When Charles I's collection was sold the cartoons were reserved for Cromwell and later reverted to Charles II. Towards the end of the seventeenth century the Mortlake works were given up, and the cartoons were installed in Hampton Court, in a gallery specially designed for them by Sir Christopher Wren. They were later moved from one royal residence to another till 1865, when Queen Victoria, on the initiative of the Prince Consort, agreed to place them on loan in the South Kensington Museum (Victoria and Albert).

Both in the tapestry works and in their frequent journeys between Buckingham House and Windsor the cartoons must have suffered considerable damage, and been the object of repeated minor restorations. These consisted chiefly of strengthening outlines, and so have not greatly changed the general effect. They do, however, make it difficult to say which parts were executed by Raphael himself. Although he must have employed several assistants, the principal parts, e.g. the head of St Peter, seem to be painted by his own hand.

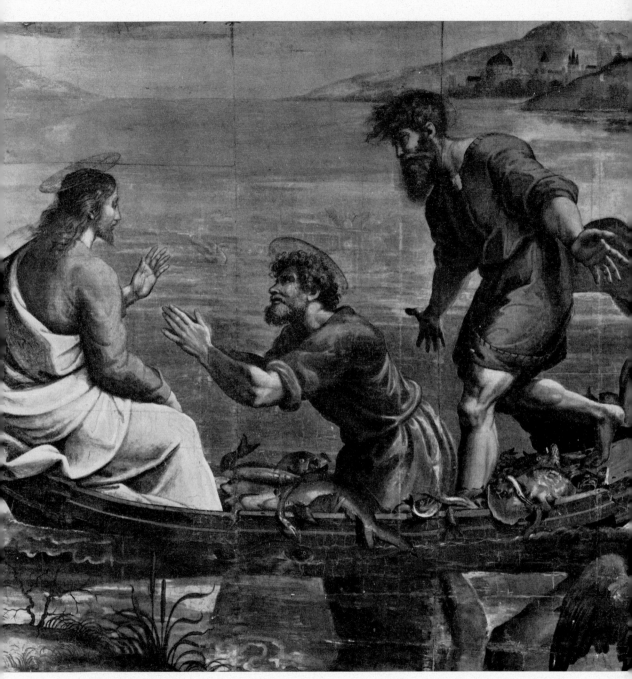

21 RAPHAEL: St Peter and St Andrew entreating Our Lord, from *The Miraculous Draught*

WATTEAU

L'Enseigne de Gersaint

PURE PLEASURE! The notion that a work of art should evoke such a response seems to us slightly improper and very old-fashioned. It takes us back to the last whispers of the aesthetic movement, when critics debated the meaning of the term 'pure poetry'. Well, if anything can be called 'pure painting' it is *L'Enseigne de Gersaint*. Before it I find myself thinking of Pater's essay on Giorgione, and groping for his words—'the sensuous material of each art brings with it a special phase or quality of beauty, untranslatable into the forms of any others'.

My first impression of the *Enseigne* is of an interplay of tone and colour so breath-takingly beautiful in its own mysterious domain that to attempt an analysis would be foolish and indelicate. But as I sit enraptured by these areas of shimmering light and shadow I fancy that I can understand some of the principles on which it is constructed. To my astonishment I find myself thinking of Piero della Francesca's fresco of the Queen of Sheba. There is the same silvery colour, the same processional dance of warm and cool tones, even some of the same detachment.

The individual colours are nameless, and a colour reproduction which pretends to itemise them misrepresents the whole. The silk dress of the lady on the left, which is the most positive note in the picture, could, I suppose, be described as lavender. But every other large area is not a colour but a mutation of tone. The lavender dress, which is cool, is completed by the warm russet of the man's waistcoat, which then passes into the cool grey of the background.

75

22 WATTEAU: Lady in the lavender silk dress, from *L'Enseigne de Gersaint*.
Berlin-Dahlem, State Museum

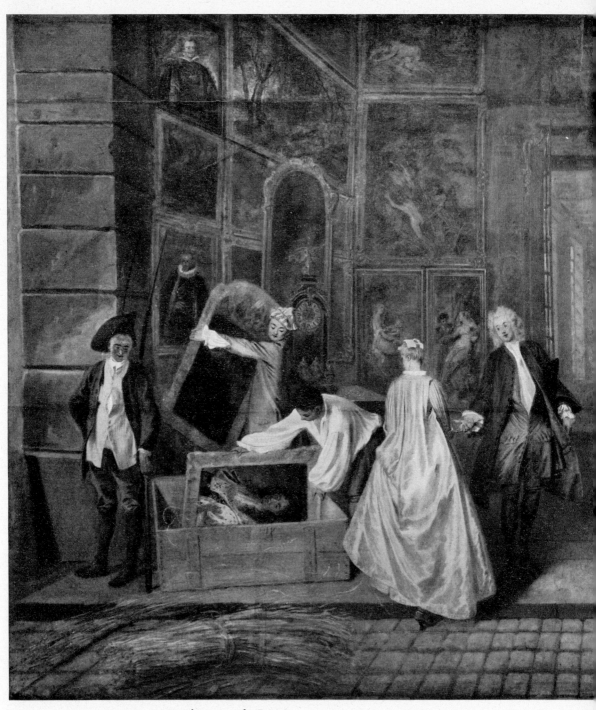

23 WATTEAU: *L'Enseigne de Gersaint*

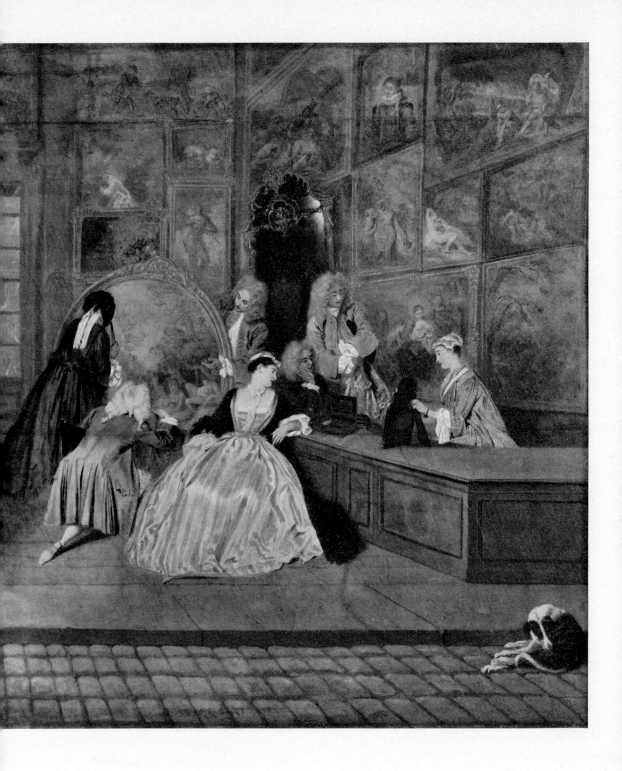

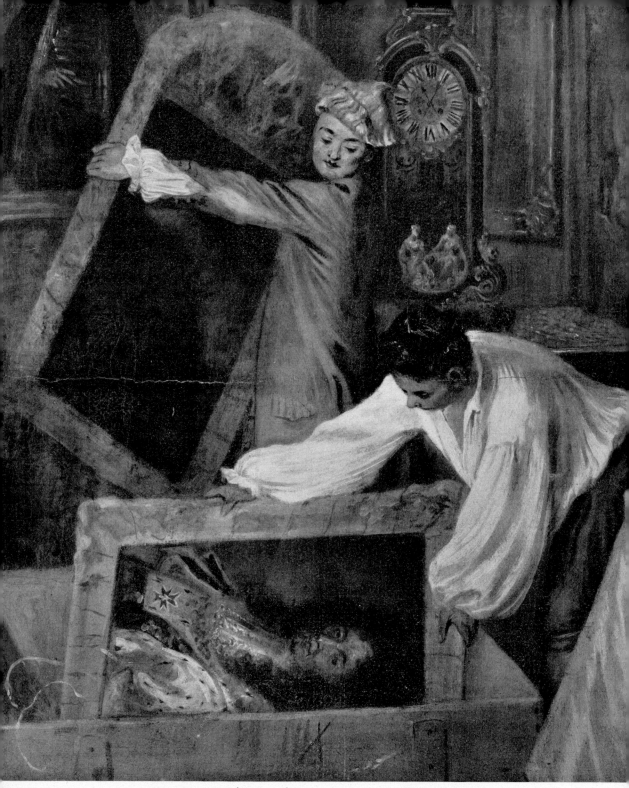

24 WATTEAU: Packing up the Grand Monarque, from the *Enseigne*

L'Enseigne de Gersaint

On the right the process is reversed. The silk dress of the seated lady, an indescribable combination of spring colours, is on the whole warm. The gentleman with his back to us is the coldest grey in the picture, but his silvery wig is relieved by Diana and her Nymphs whose muted pink bodies he is admiring. In and out, back and front, white, cool, warm, cool, black, cool, warm, black: it is a design as strict as a fugue.

But of course Watteau has not allowed this formality to become apparent. He has introduced subtle variations, and he has disguised the symmetry of tone by a contrast in subject, between the two forms of activity in Gersaint's establishment, the fine art of salesmanship, revolving round the elegant picture-frame, and the mechanical art of *encaissement*, based on the rough wooden packing-case. Moreover, once our eyes have grown used to the general plan, we become aware of small notes of colour at first imperceptible in the grey. From beneath the standing lady's lavender cloak there appears an emerald green stocking; beside the seated lady's elbow is a lacquer-red box. Like exceptional instruments in a large orchestra, they may pass unnoticed until we read the score, yet they have given depth and vibration to the whole.

These reflections on tone and colour, which come first to mind before the *Enseigne*, would, I think, have occurred to me much later if I had been looking at any of Watteau's other paintings. Before them I should no doubt have found myself thinking about the grace and pathos of his figures, and the touching world of make-believe which was his peculiar creation. Even Roger Fry found himself thinking less about the plastic qualities of *L'Indifférent* than about the result of his encounter with *La Finette*. Of course there is a poetic element in the *Enseigne*, and a delicate interplay of human relations, but these are secondary to the pictorial qualities. In this, as in many other respects, it is unique in Watteau's painting: we must ask what has happened.

L'Enseigne de Gersaint was, in effect, Watteau's last picture. In 1719, already afflicted with consumption, he had taken the strange

fancy to visit England, 'that veritable home of the disease'. Perhaps he came to consult the famous Dr Richard Mead; certainly Dr Mead owned two of his pictures, although whether they were painted in England seems to me very doubtful. These months of residence in London are inexplicable, and Watteau's friends felt that they had changed his character. He returned to Paris in the spring of 1720 and the sequel can best be told in Gersaint's own words.

'In 1721, on his return to Paris, in the first years of my business, he came to me and asked if I would allow him to paint an over-door to be exhibited outside my premises, in order (these were his words) to take the numbness from his fingers. I felt a certain distaste in granting his request, as I should have liked him to be occupied with something more solid; but seeing that it would give him pleasure, I agreed. The success of this piece is well known. It was all done from nature, and the attitudes were so truthful and easy, the arrangement so natural and the grouping so well understood that it caught the eye of passers-by, and even the most skilful painters came several times to admire it. It was the work of eight days, and even so he worked only in the mornings, his delicate health, or rather his weakness, not allowing him to paint any longer. It is the only one of his works which slightly sharpened his self-esteem: he admitted this to me unhesitatingly.'

Soon after painting the *Enseigne* Watteau relapsed into a state of languor, and, fearing that he might inconvenience Gersaint, he insisted on retiring to the country. Gersaint found him a house at Nogent, near Vincennes, his birthplace, and there in the following summer he died, at the age of thirty-seven.

Gersaint's narrative suggests several reasons why the *Enseigne* is exceptional. It was painted fast, and as a rule Watteau had painted slowly; it is on a large scale (over ten feet long), and the best of Watteau's other pictures are small; it was painted from nature and Watteau's usual procedure was to piece together his pictures from drawings in his sketch books, many of which he used several times.

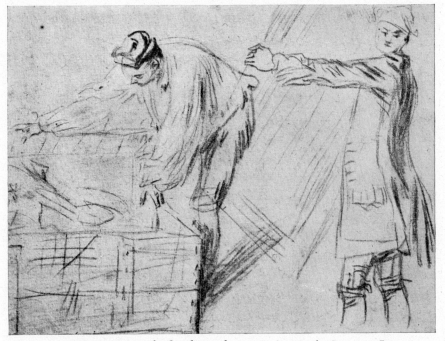

25 WATTEAU: Study for the packers. Paris, Musée Cognacq-Jay

Of the two surviving drawings for the *Enseigne*, one, a study for the lady in lavender, may have been done earlier, but the other, a sketch of the packers, has a haste and urgency unique in Watteau's work. It is perhaps the only one of his drawings not done for its own sake, but with another end in view. Most revealing of all, Gersaint's account shows us that the *Enseigne* was painted after a period of inaction and as a result of a strong inner compulsion.

Several of Watteau's friends described his character with the classical precision inherited from the seventeenth century, and the results are remarkably consistent. He was all that the apologists of the aesthetic movement felt an artist should be: proud, delicate, solitary, dissatisfied with his work. Gersaint had great difficulty in getting him to relinquish his pictures before he could rub them out,

and he frequently complained that he was being overpaid for such trifles. He had a passion for independence. When his pedantic friend, the Comte de Caylus, gave him a lecture on his unstable way of life Watteau replied, "The last resort is the hospital, isn't it? There no one is refused admission"; an answer which, as the de Goncourts truly said, brings him close to our own time.

He knew he was consumptive, although how early the disease began to affect him it is hard to say. One may fancy that at a certain point in his work the tension increases. The hands of his figures, which, far more than their faces, betray their restless inner life, seem to grow more strained and nervous, so that the skin is stretched tight over the bone. In fact, arguments based on chronology are inconclusive, as Watteau's drawings and pictures are extremely difficult to date; and the second version of the *Embarquement pour Cythère*, which was certainly painted when his health was failing, is the most masterly and vigorous of all his works.

Yet the *Enseigne* suggests that while his fingers were growing numb in the London fog, he was passing through a crisis of the creative mind. Whatever its causes, this crisis manifested itself in two ways, the need for new subjects and the search for a new basis of arrangement. Watteau (it is the first thing said about him by every writer since the de Goncourts) is the poet of illusion. His subjects are make-believe, his figures are half in fancy dress and his most realistic works are those which represent actors. Owing to his extraordinary skill in delineating the tangible reality of details—hands, heads and the texture of silk— these illusions became credible and offered the most delightful escape from life since the time of Giorgione: the vogue of his imagery began with his first exhibited picture and lasted a century. When one considers that Fragonard, who, in his best paintings, is still cultivating Watteau's garden, was born ten years after Watteau died, one can see how tenaciously eighteenth-century taste clung to the myth of the enchanted picnic. Watteau was, and surely felt himself to be, a prisoner of the fashion which he had created; hence his impatience with

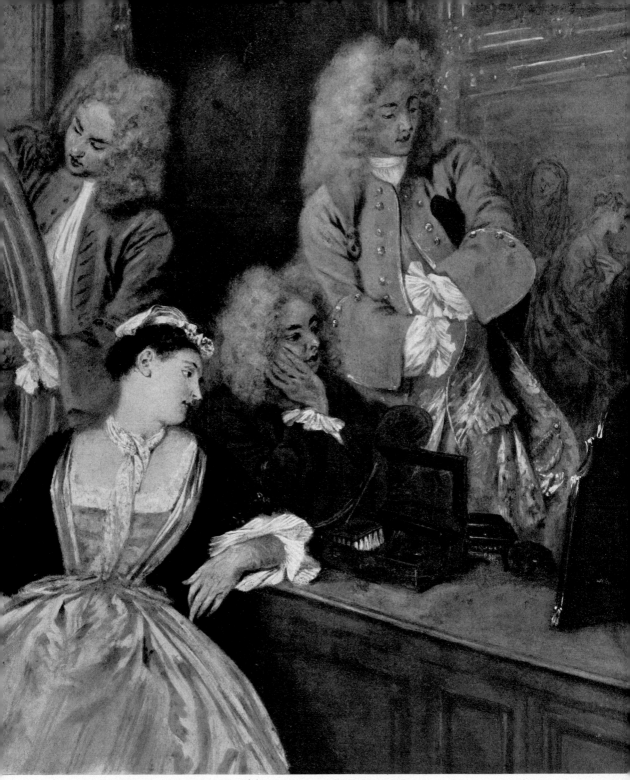

26 WATTEAU: Gersaint and his customers, from the *Enseigne*

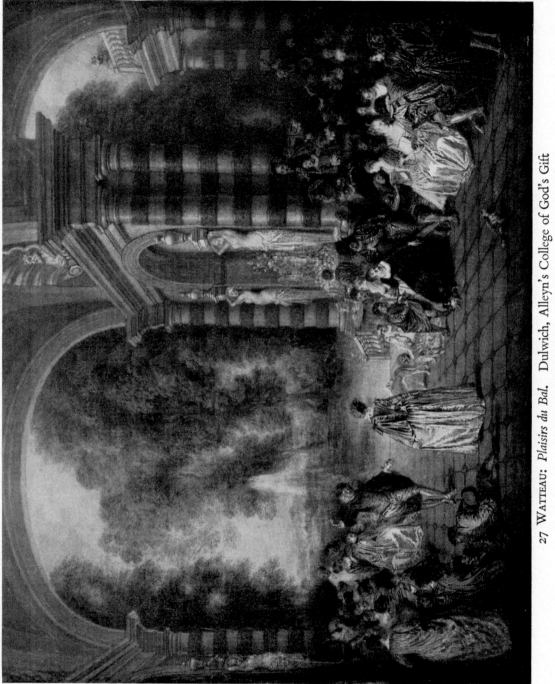

27 WATTEAU: *Plaisirs du Bal.* Dulwich, Alleyn's College of God's Gift

(By kind permission of the Board of Governors)

all that he had done, and hence the request which so horrified Gersaint, that his last picture should not be a *fête-champêtre*, but a shop sign.

Stylistically, too, he had reached an impasse. Caylus has been derided for saying that he was deficient in the art of composition; but from the academic point of view he was right. Watteau never mastered the baroque trick of relating figures in depth. In his large pictures the groups are dotted about in rows, with a back-cloth behind them; only in his small pictures, where all the figures are in the same plane, is there a perfect feeling of unity (a visit to the Wallace collection will confirm this). The great exception is the *Embarquement*, where Watteau has had the inspired idea of making his departing figures vanish down the side of the bank and reappear by their boat, thus avoiding the problem of the middle distance. It is a device of mannerist painting perfectly appropriate to the subject, but not to be repeated.

At the same time he turned for help to the formality of an architectural setting, and the first result was the *Plaisirs du Bal* at Dulwich, the most beautiful Watteau in England. This, we may suppose, was the solution which was working in his mind during his months of numbness, and which he was so eager to realise when he went to Gersaint on his return.

The *Enseigne* employs the schematic perspective of fifteenth-century Florence, which had been revived by the Dutch some sixty years earlier. The setting is a box, with walls converging on a central vanishing-point, and with a chequered foreground to lead in the eye. But this box is also a stage (it was in fact in the theatre that the devices of Albertian perspective had their most prolonged success); and in the disposition of the figures, which Gersaint found so natural, Watteau has used the arts of the stage director. What a genial piece of stage-craft, to put the farmer's boy, who brought the straw for the packing-case, in front of the proscenium arch. By thus establishing his actors on a stage he has preserved his detachment, in spite of the fact that they are no longer creatures of illusion, but real and familiar.

85

This formalised setting has allowed him the symmetrical interplay of tone and colour which was the first thing to strike me in the *Enseigne*. But by a stroke of inspiration the walls of his perspective box do not imprison the eye, for they are covered with shadowy promises of escape, the pictures in Gersaint's gallery. Interiors of picture galleries were a favourite subject in an age of enlightened collectors, for they both served as a record and multiplied the pleasures of identification. But the pictures in Gersaint's shop are subordinate to the tonality of the whole. We can guess at the authorship of one or two—Rubens, Ricci, Mola—and Watteau has enjoyed making fanciful transcriptions of their designs; but they emerge from the penumbra only far enough to enrich the tone of the background with a play of muted colour.

The value to Watteau of this classical framework lay in the fact that he was not naturally a baroque artist. This is obvious enough if one compares his drawings with those of Rubens. Watteau did not see form as a series of flowing curves but as lines drawn taut as a bow-string. The poses and gestures of his figures may suggest easy movement, but the substructure of even his hastiest sketch is severe. In the *Enseigne* the standing lady and the kneeling connoisseur are examples of this rectilinear severity, and all the figures, except the packer in the white shirt, have an underlying sharpness of accent. They are more at home in a perspective box than in a feathery park.

But once again Watteau has concealed this severity by the grace of his handling. The *Enseigne* is painted lightly and rapidly, and without the rich texture of his other pictures. I find it hard to believe that the ladies' silk dresses took him only eight days, but the other figures have the freshness of his drawings. In this Watteau has achieved one of his aims, for we know that he valued his drawings more highly than his pictures, and was tormented by the fact that he could not preserve their qualities in paint. The greater naturalness of the figures, which Gersaint mentions in his description of the *Enseigne*, was really a liberation of Watteau's own nature. It is as if all the skill which he

has hitherto felt bound to keep in reserve, as a jewel-setter might lock up his precious stones, had been suddenly poured out quite freely, as if jewels were as common as violets and anemones. Perhaps that is why the *Enseigne*, in spite of the frivolity of its subject, gives one the feeling of an extremely serious picture. Like the late works of Titian, Rembrandt and Velasquez, it consummates some mystic union between the artist and his art.

L'Enseigne de Gersaint, by Antoine Watteau (1684–1721), is in oil on canvas, $63\frac{3}{4}'' \times 121\frac{1}{4}''$ (1.62 × 3.078 m.). It was commissioned by Watteau's friend, the picture dealer Edmonde-François Gersaint, as a shop sign over the door of his gallery, No. 35 Pont Notre-Dame. We know from a painting by Hubert Robert that the ground floor of these shops had arched fronts, and Watteau's painting was originally designed to fit into one of these. This is still visible, but adaptation to a rectangle is so well done that it appears at first to be by Watteau himself. On the other hand, an engraving of the *Enseigne* made by Pierre Aveline in 1732, although it shows the picture as a rectangle, marks the original arc, and seems to imply that the rest was not Watteau's work. If so, it must have been done by Pater, who is known to have made a copy.

Gersaint sold it almost immediately to the famous connoisseur Julienne. Between 1745 and 1750 it was bought by Friederich Rudolf von Rothenburg for Frederick the Great's collection at Potsdam. Before 1760 it was exhibited in the Palace of Charlottenburg where, in order that it might be part of the rococo decoration, it was cut in two. It remained, in two pieces, in the Imperial German collection until 1952, since when it has been exhibited in the State Museum of Berlin-Dahlem.

Gersaint's gallery was called *Au Grand Monarque*, and presumably there is an allusion to this in the portrait of Louis XIV which is being *encaissé* on the left. On the other hand, writers on the *Enseigne* have sometimes interpreted this as an allegory of the Louis Quatorze style being packed away and the new rococo style taking its place.

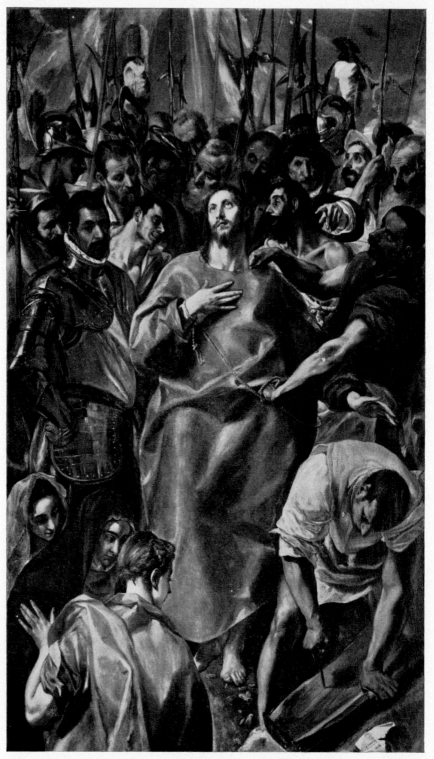

28 EL GRECO: *The Espolio*. Toledo Cathedral

EL GRECO

The Espolio

IT SHINES like an enormous jewel. Spanish cathedrals are full of jewellery—crowns and chalices and encrusted altars—but their splendour becomes boring, like a lazy, monotonous chant. El Greco's jewel is also a passionate cry. This huge ruby set in topaz, aquamarine and smoky quartz is also the seamless garment of Our Lord, which is about to be torn from Him. The emotion I feel as I stand dumbfounded before the *Espolio* in the sacristy of Toledo Cathedral is that same amalgam of awe, pity and sensuous excitement which I feel in reading certain poems by Crashaw and Gerard Manley Hopkins. The richness and iridescence of the materials, by challenging my senses, give me a flash of spiritual insight which a more reasonable consideration could not achieve.

This comparison with jewellery occurs to everyone who looks at the *Espolio*, and is not an isolated fancy, for one has a feeling that the colour and disposition of jewelled bindings or enamelled altars were often in El Greco's mind when he began a composition. Little as we know about his origins, we can at least be sure that he was brought up in the Byzantine tradition of art. How far this influenced the imagery of his later paintings seems to me debatable; but I believe that he did retain throughout his career that fundamental premise of Byzantinism, that beauty of materials—gold, crystal, enamel and translucent stones —gives art its splendour and its power to arouse our emotions.

He made his way into Europe through the meeting-ground of East and West, Venice; but we have no idea how old he was when he got there. Indeed we know absolutely nothing about him until

El Greco

November 10, 1570, when the Roman miniature painter Giulio Clovio recommended him to his patron Alessandro Farnese as 'a young Cretan, a disciple (*discepolo*) of Titian'. Can this be taken to mean that Titian, at the age of ninety, with a well-organised studio, had accepted the young Cretan as a pupil? Or does it mean only that El Greco was the devout admirer of Titian, which would commend him to Alessandro Farnese? Of the second fact there can be no question. The later paintings of Titian, the Munich *Crowning with Thorns*, or the *Annunciation* in S. Salvatore, painted probably when El Greco was in Venice, have a burning beauty of colour which plays on the emotions as El Greco felt it should. Titian certainly meant more to him than Tintoretto and Bassano, although a few tricks of mannerism which appear in the work of all three give an illusion of similarity.

What else he saw in north Italy is only conjecture, although I think he must have looked attentively at the work of Tibaldi in Bologna, and perhaps at the Correggios in Parma. And then in 1570 he was in Rome. Michelangelo had died six years earlier, but Roman art was still reeling under the impact of his genius. The painters worked in a post-Michelangelesque trance. They extracted from his designs hieroglyphics of the human body and a repertoire of poses and gestures which they used without any of his original conviction. Not since the early middle ages had European art departed so far from visual and substantial truth; and this unreality, as great as that of his own Cretan icon painters, certainly appealed to El Greco more than the solid abundance of Paul Veronese.

In one respect the Roman mannerists must have seemed to him inadequate—in their colour. Following, as they believed, the example of their master Michelangelo, they considered colour as a mere bedizening of form and a concession to the senses which detracted from the high seriousness of art. We may suppose that it was this which led El Greco to speak disparagingly of Michelangelo, for even if he did not say (as was reported of him) that he could repaint the *Last Judgement* with more decency and no loss of effect, he unquestionably

90

29 EL GRECO: Man preparing the Cross, from *The Espolio*

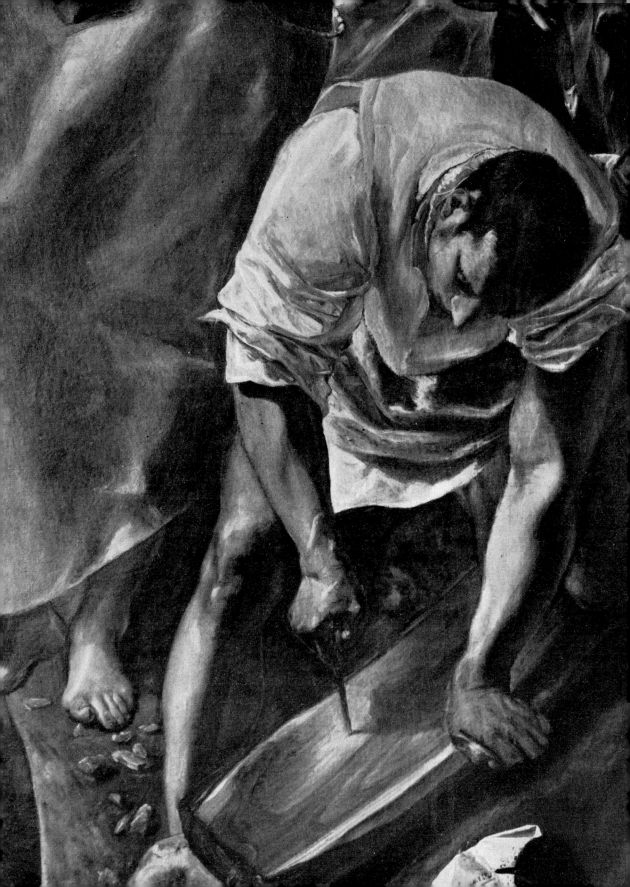

did say to Pacheco that Michelangelo was a good man, but didn't know how to paint. But he could not shake off what Blake might have called the outrageous demon of Michelangelo. His naked figures, sprawling, inverted, drastically foreshortened, are often copied directly from the despised *Last Judgement*; and without Michelangelo's frescoes in the Pauline Chapel the *Espolio* would have taken a different form. I feel this in the man bending forward to prepare the Cross, in the three women who emerge from the bottom of the frame, and above all in the effect of life pressing round a dedicated victim, which is also the theme of Michelangelo's *Crucifixion of St Peter*. As the memory of this sublime work, with its circle of doomed humanity in a desert concentration camp, passes through my mind, I look again at the *Espolio* and realise how completely different it is from anything in Italian painting.

The first difference lies in the treatment of space. Instead of solid figures occupying a definable area, as they had done in Italian art since Giotto, and still do in the dizzy perspectives of Tintoretto, El Greco's figures fill the whole surface of the picture with shallow intersecting planes. The abstract substructure of the picture—and that in the end is where the force of any picture lies—is more like a cubist Picasso of 1911 than a work in the Renaissance tradition. The conflicting stresses of the planes, and the way in which one suddenly shoots behind another, lead us to look all the more eagerly at the central area of red.

At this point I think once more of the *Espolio* in terms of its subject and become more fully aware of the vividness of El Greco's imagination. It is the moment at which Christ is about to be deprived of His splendid earthly raiment, which is also the symbol of His kingship. The world of men presses round Him. Two of them look in our direction and seem to act as intermediaries: a stupid, puzzled military man and an elderly administrator, his face bristling with negation, who points a commanding finger at Our Lord. For the rest, a few are brutal and join in the persecution with relish, but the majority are ordinary men from the streets of Toledo and the surrounding fields,

30 EL GRECO: The administrator, from *The Espolio*

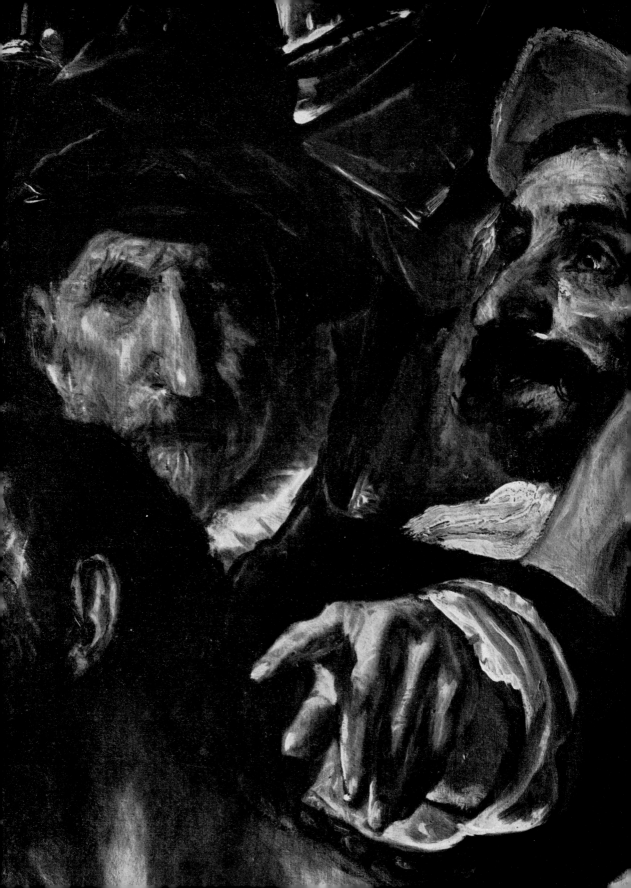

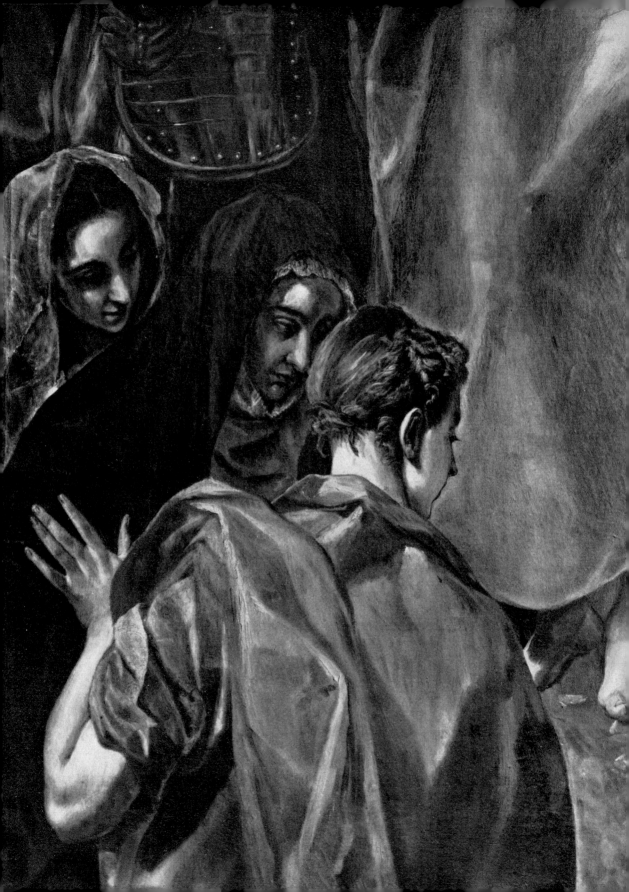

looking exactly as they did when they came to be painted in El Greco's studio. It is the number and closeness of the heads that is terrifying, for they have become a crowd and as such they resent Our Lord's isolation. His thoughts are already concentrated on another world. The gaze or gesture with which this is expressed show some of the rhetorical pietism of the Counter-Reformation, and used to cause me a moment's embarrassment. They do so no longer, but I record the fact as it may be one reason why the *Espolio* has been less admired outside Spain than El Greco's other masterpieces.

In the lower half of the picture, separated from the crowd, are those directly concerned with the sacrifice, the Marys and the executioner who prepares the Cross. Between them, painted with extreme delicacy, is Christ's foot, and I notice that the three women are looking fixedly at the nail with which it will soon be pierced. But, like the men, their faces show no emotion. That is one of the strange features of the *Espolio*. One has only to think of how other great masters of Christian drama, from Giotto and Giovanni Pisano to Titian and Rembrandt, would have treated the theme, to recognise the dreamlike unreality of El Greco's imagination. Apart from a conventional heavenward rolling of the eyes, the faces of his figures are without expression. He is like a classical dramatist who does not feel it necessary to distinguish the idioms of different characters. In fact the emotions of his figures are expressed through their gestures, and of this the *Espolio* gives a most moving example, the gesture of Christ's left hand which, passing under the arm of His tormentor, pardons the executioner at work on the Cross.

El Greco received a part payment for the *Espolio* in 1577. It is the first surviving record of his having gone to Spain and settled in Toledo, and he may well have been living there for some time before being given the most important commission which the city had to offer. Two years later he brought a lawsuit against the cathedral authorities in order to obtain further payments. The expert witness was a Toledan

31 EL GRECO: The three Marys, from *The Espolio*

goldsmith named Alejo de Montoya who said that the *Espolio* was one of the best pictures he had ever seen, and estimated its value at a large sum, which apparently was paid. It seems that the young Greek was accepted by the Toledans as a great master and one of the glories of their city. He may well have hoped to take the place of his master, Titian, in the confidence of Philip II, but in this he was disappointed, for the King was understandably alarmed by that extraordinary work, the *Martyrdom of St Maurice*, and preferred the commonplace and circumstantial style of Titian's Spanish pupil, El Mudo. Ecclesiastical authorities, however, continued to patronise El Greco, either because he provided images of fashionable ecstasy, or because nothing better was available, or because he was obviously a man of superior powers: perhaps from a mixture of all three, for the motives of a committee ordering a work of art are always very mixed. There is evidence that he was admired by the finest spirits of the day; and Toledo, at the time of his arrival there, offered the most intense spiritual life in Europe. St Theresa of Ávila, St John of the Cross and Frey Luís de León were all in Toledo when the *Espolio* was being painted. At a later date Góngora, Cervantes and Lope de Vega lived in the town, and El Greco probably met them. There is no question of his highly eccentric style being (as is sometimes the case) the result of provincial isolation.

At the same time it is arguable that El Greco exploited his isolated position, which for thirty-five years gave him something like a monopoly of painting in the district. It is even possible to say that he exploited his visionary power. Like other painters whose ideas have come to them with unusual completeness and intensity—Blake is an obvious example—he was prepared to repeat individual figures or whole compositions as often as was required. This is a characteristic of all magic art: once the image is charged with its meaning it need not, or must not, be varied. The magic animals in palaeolithic cave paintings have identical outlines in northern France and southern Spain. No doubt El Greco was satisfied that he gave his clients good magic. He had, Pacheco tells us, a large room containing small replicas in oil

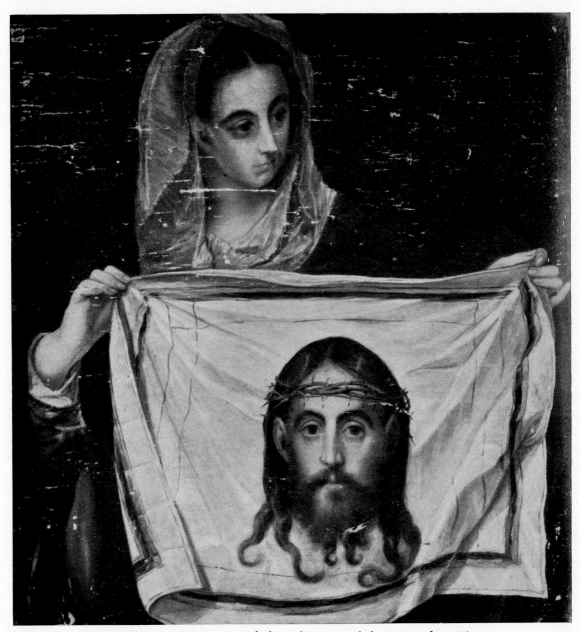

32 EL GRECO: *St Veronica with the Sudarium.* Toledo, Museo de S. Vicente

of all the pictures he had ever painted in his life. His customers could take their choice. Of the *Espolio*, there still exist eleven replicas of all sizes, and five versions in which the upper half has been made into an oblong picture. Individual figures are treated in the same way. The Virgin's head is used again in groups of the Holy Family; the left-hand Mary appears several times as St Veronica with the sudarium. With subjects more in demand the numbers increased; there are over twenty replicas of the St Francis in meditation, most of them the work of assistants. However 'modern' El Greco may be in some respects, he certainly would not have subscribed to our modern notion of 'a work of art'. His pictures were partly objects of devotion, icons in which the image represented an unalterable fact; and partly saleable commodities, which could be made wholesale once the prototype had been established.

And yet the critics of the 1920's who saw in El Greco the precursor of modern painting were right. Partly owing to the coincidence in his formative years of two non-realistic styles—the Byzantine and Mannerist—and partly owing to a naturally metaphysical turn of mind, El Greco was the first European painter to reject the main premises of the classical tradition. He thought surface more important than depth, and suddenly brought a head to the front of a design if it suited him; he thought colour more important than drawing, and scandalised Pacheco by saying so; and he sought to communicate his emotion by pictorial means, even if it involved distortion or an almost incomprehensible shorthand. Since the early middle ages no other painter had dared to let his sense of rhythmic necessity carry his hand so far away from observed facts, or rather, from that convenient version of the facts which had been sanctioned by academic convention. In the *Espolio* these characteristics are still contained in the habitual forms of mannerism: that is why for three hundred years it was the most acceptable of his works. In his later work, when he had evolved his own handwriting and his brush scrawled across the canvas like a storm across the sky, he seems closer to our own unsettled feelings;

but his imagination never burnt more intensely than in the holy fire of Toledo Cathedral.

El Expolio, by Domenikos Theotokopoulos, now known as El Greco (1541–1614), is in oil on canvas, $107\frac{1}{2}'' \times 68''$ (2.73 × 1.73 m.). It was painted for the high altar in the sacristy of Toledo Cathedral, where it has remained to this day. On the 2nd of July, 1577, El Greco received 400 *reals* on account for his work on the picture. In order to obtain full payment he took a lawsuit against the cathedral authorities, and on June 23, 1579, was awarded 3,500 *reals*. The *Espolio* continued to be one of his most admired works, and some of the numerous replicas mentioned above (p. 98) belong to a much later date in his career. Francisco Pacheco (1564–1654) was a painter and author of a book on the Art of Painting, published in Seville in 1649. He was also the master and father-in-law of Velasquez.

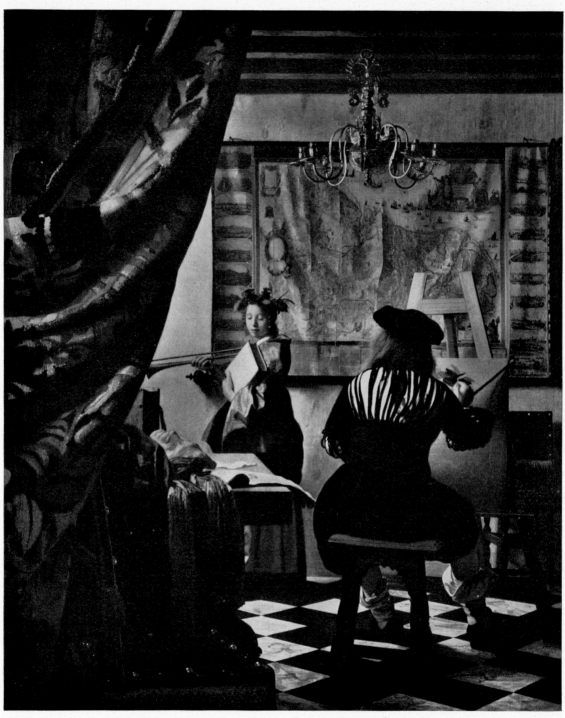

33 VERMEER: *A Painter in his Studio*. Vienna, Kunsthistorisches Museum

VERMEER OF DELFT

A Painter in his Studio

I SUPPOSE that the natural feeling of anyone looking at Vermeer's *Painter in his Studio* for the first time would be pleasure in the day-light which falls on the patient model and passes over the map of Holland on the wall, like an incoming tide over the sand. We enjoy a moment of heightened perception, a simple pleasure of the eye; and Vermeer's early admirers were thus deluded into thinking that he was a simple artist.

Yet from the start all sorts of complicating factors have entered in. Before my eye can reach the peaceful figure in blue, with her yellow book, it has had to leap some curious obstacles, the swag of curtain, the bizarre silhouette of the painter and the objects on the table, foreshortened almost out of recognition. As I gradually become conscious of these details I begin to notice how curiously they are seen and related to one another. Each shape has that clearly defined identity which one sees in the drawings of children (or did before they were encouraged to express themselves). One still sees things in this way when one is half awake and looks with a sleepy eye at the knob of a bed or a lamp, without quite recognising what it is. Vermeer has retained this early morning innocence of vision and united it with a most delicate perception of tone.

At this point I begin to think what other painters dwelt with this kind of fascination on curious shapes, and the first two names that come to my mind are Uccello and Seurat. I remember in Uccello's battle pieces that there are foreshortened objects similar to the book and the plaster head on the table in front of the model; there are even trumpets,

almost exactly like the one in her hand. The difference is, of course, that Uccello's method of uniting his flat shapes is based on geometry, not on tone. He relates them all to certain ideal geometric constructions—what Renaissance theorists called the regular bodies and this was all part of what he understood by the word 'perspective'. Vermeer was interested in perspective, too, and deduced from it many similar patterns; but he is not interested in regular bodies and, being a post-baroque artist, his shapes are more often irrational, as one can see by comparing the artist's bulbous breeches with the rump of one of Uccello's horses. Seurat shared Vermeer's interest in tone, but he was by instinct the organiser of large flat surfaces. He did not wish to take half the side off a hollow box, as Vermeer did; and the two only meet in the impersonal fascination which objects like the ends of parasols, and the knobs on chairs, had for them both.

But these critical speculations have led me too far from the picture itself, and I must now look at it again to see what it can tell me about Vermeer. This is one of the rooms in which he painted. There seem to have been two, for window-panes with two different kinds of leading are to be found in both early and late pictures; and they may have been one above the other, as the light always falls from the left, and has much the same quality. His perfect control of space makes them look big, but if one measures the squares of the floor they turn out to be quite small, which accounts for the objects in his foregrounds coming so close to the eye. Before beginning work on a picture he set the scene, arranging the furniture, looping the curtains, draping chairs and tables and hanging on the main wall a different map (we know four of them) or a painting from his collection. Just as Poussin worked out the grouping of his figures on a model stage, so Vermeer perfected his compositions before he sat down to paint them. His father had been an art dealer, and on his father's death Jan took over the business. In consequence he had plenty of works of art with which to furnish his interiors and took a special interest in their presentation. Into this setting so carefully prepared he put a figure. He was happiest

34 Uccello: Detail of a *Battle Scene*. London, National Gallery

with only one, because in this way he could avoid any dramatic tension; but if, for the sake of variety, he introduced other figures he liked one of them to turn his back on us so that the disturbing impact of two glances was invisible. On the rare occasions when a human relationship is represented, as in a picture at Brunswick, it seems to have caused him disgust.

During the long period of preparation for each work he evidently considered how a scene of everyday life could take on an allegorical significance, and he used to express this in an oblique way by the

103

picture in the background or by some unremarkable detail. But in the *Painter in his Studio*, the subject itself is the painting of an allegory. The model represents Fame and her figure is going to fill the canvas on his easel. He has begun by painting her wreath of laurels. This very still and silent maiden, who would surely never distort the sweet oval of her face by blowing a trumpet, is an image of Fame which confirms what we know of Vermeer's character. Almost the only contemporary record which is in the least revealing is an entry in the diary of a French gentleman named Balthasar de Monconys in 1663: 'At Delft I saw the painter Vermeer who had none of his works to show me; but we found one at a baker's. He had paid six hundred pounds for it, although it is only one figure and I would have thought it overvalued at six pistoles.' Fame! Already in 1663 Vermeer was famous enough for this well-known connoisseur to make a long detour. But he would not show the visitor a picture: for I think it is out of the question that none of his works was available. On the contrary, we have no evidence that his pictures ever left his studio (the one at the baker's was a deposit against the household bills), and in the sales after his death quite early works were included with late ones. His business as an art dealer brought in enough money to support his nine children; and allowed him to go on painting as he liked, undisturbed. No other great artist has had so fine a sense of withdrawal.

Naturally the painter in the Vienna picture turns his back on us and his fluffed-out hair does not even allow us to guess at the shape of his head. We cannot even be sure whether it is Vermeer himself or a model. But what about that costume! Here, for once, he may have given himself away; for this beribboned doublet is remarkably similar to the one worn by a young man on the left of the Dresden *Procuress*, painted over ten years before. Is it really possible that the grinning youth in this early picture is our immaculate artist? Did this jack-in-the-box once emerge, to be shut down and firmly suppressed for ever? If so, it would account for the obsessive character of the painter of Fame, crouched at his easel like a gigantic cockroach, which

35 VERMEER: *The Procuress*. Dresden, Gemäldegalerie

36 VERMEER: Detail from *A Lady at the Virginals*. Collection H.M. The Queen

so disturbed Mr Salvador Dali that he has introduced him into his Freudian concoctions almost as often as Millet's *Angelus*.

We may speculate about Vermeer's character: we know him as an eye. *Mais quel œil !* For the first, and almost for the last, time in European painting, it is an eye which felt no need to confirm its sensations by touch. The belief that what we touch is more real than what we see is the basis of drawing. A firm outline denotes a tangible concept. Even Caravaggio, in his revolution against academic art, retained the concept of a form enclosed by an outline. Vermeer, the least Caravaggiesque of characters, was far more radical. When an area changed colour or tone he noted the fact without prejudice and without any indication that he knew what the object under scrutiny really was. Such visual innocence is almost unnatural, and one is tempted to look for a mechanical explanation. I think it almost certain that Vermeer used the device known as the camera obscura, by which the coloured image of a scene could be projected on to a white surface. Even if he did not use this machine (and they were said to be very difficult to employ) he must have looked at the scene through a sheet of ground glass in a dark box. This would account not only for the simplification of tone but also for the way in which highlights are rendered as small globular dots of paint. One finds the same technical trick in the paintings of Canaletto, who is known to have used a camera obscura, and anyone who has focussed an old-fashioned camera will remember how the sparkle of light appears as little shining globules overlapping the forms from which they are projected.

But although this explains how Vermeer sustained his visual impartiality, it does not explain the qualities for which we value him most. There is, for example, his flawless sense of interval. Every shape is interesting in itself, and also perfectly related to its neighbours, both in space and on the picture plane. To see pattern and depth simultaneously is the problem that exercised Cézanne throughout half his career, and many layers of agitated paint were laid on the canvas before he could achieve it. Vermeer seems to glide through these

deep waters like a swan. Whatever struggles took place have been concealed from us. His paint is as smooth, his touch as uncommunicative, as that of a coach-painter. It is impossible to tell what calculations underlay these beautifully tidy results. His rectangles, for example—pictures, maps, chairs, spinets—fall together with the same kind of harmonious finality that we find in the work of Mondrian. Is this the result of measurement or of taste? Perhaps geometry played a part, but in the end the harmony of shapes must flow from the same infinitely delicate sense of relationships as the harmony of colours.

Everything in Vermeer's picture is intimately known and loved. 'I should paint my own places best,' said Constable, and what he felt about the slimy posts and old rotten planks of the Stour, Vermeer felt about the clean white walls and chequered floors of Mechelen, his beloved house on the market square of Delft. In that setting he painted the things he loved—his wife, his friends, his furniture and favourite pictures. He is the great amateur. He never sold a picture; he painted solely to please himself, and it took two hundred years before posterity, or to be more precise the French critic Thoré, noticed that he was in any way different from the successful Dutch genre painters of the period.

But nothing could be less amateurish, in the popular sense of the word, than the *Painter in his Studio*. It is the largest and most complex of his pictures, and there is material in it to lead the eye into many agreeable explorations. There is the shape of the painter's shoes, the red tip of his mahlstick and the blue leaves which are all of Fame that he has so far recorded; there is the chandelier, which reminds us of that ancestor of visual painting, Van Eyck's *Arnolfini*, and the mysterious plaster cast of a head (certainly not, as is sometimes said, a mask of Comedy), and finally, like a slice of plum cake at the end of this delicate meal, the thick curtain of tapestry, which he seemed to feel was complementary to the black and white diamonds of his floors. All this is fascinating but it would be meaningless without one indescribable element, the daylight.

We are back where we began, but with the recognition of how

IV VERMEER: Fame. Detail from *A Painter in his Studio*

much more mysterious this achievement is than we had supposed. Why the tones of ordinary daylight are so seldom rendered in paint it is difficult to say; the fact is that even the most accurate eyes of Vermeer's own day—Terborch or de Hooch—did not achieve it. Terborch's light is always artificial, de Hooch's a little yellower than the truth. The reason may be that Vermeer is one of the few great painters whose colour is basically cool. Ordinary daylight is cool, but the number of colourists who have based their harmonies on the blue, grey, white and pale yellow of a window facing north is very small. Piero della Francesca, Borgognone, Braque, Corot in his figures, and, to some extent, Velasquez are the names that come to my mind; and as I think of them I realise that cool colour is not a visual preference, but expresses a complete attitude of mind, for all these painters have something of Vermeer's stillness and detachment. In his studio the blue dress and yellow book of Fame, quietly established before the silvery grey of the map, are as much an assertion of faith as the blood-red tunic of Christ in El Greco's *Espolio*.

A Painter in his Studio, by Jan Vermeer of Delft (1632–1675), is in oil on canvas, $51\frac{1}{4}'' \times 43\frac{1}{4}''$ (1.30 × 1.10 m.). The picture was unsold at Vermeer's death. A few months after, his widow transferred it to his mother as security for a loan of 1,000 florins. It came to Vienna in the eighteenth century in the collection of Baron Gottfried von Swieten, and was bought in 1813 by Johann Rudolf Count Czernin, as a work of Pieter de Hooch. It remained in the Czernin collection till 1942, when it was taken to Berchtesgaden by Hitler.

The name Pieter de Hooch is inscribed on the rung of the stool on which the painter is sitting, and this has sometimes been taken to imply that this artist is represented. More probably it is a fraudulent signature added at a time when Vermeer's name was forgotten. Vermeer's own signature is on the map, just behind the model's collar. Recent scholars have tended to identify the model as Clio, the muse of History, and have thought that the objects on the table are emblems of the other muses. From this they deduce that the picture is an allegory of the art of painting, and is in fact the work referred to in the inventory of 1675/6 as 'De Schilderconst'.

Some of the more delicate parts of the picture, e.g. the model's head, have been rubbed down in an old restoration, and are lightly repainted.

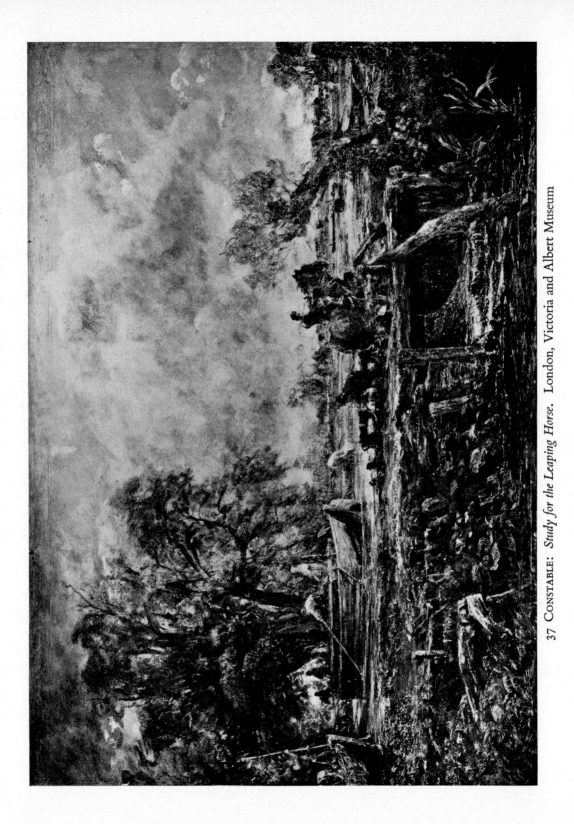

37 CONSTABLE: *Study for the Leaping Horse.* London, Victoria and Albert Museum

CONSTABLE

Study for *The Leaping Horse*

I<small>T IS</small> the most English of pictures, wet, earthy, romantic and resolute, and to an eye educated by the Impressionists it looks dark. It is also much bigger than any Impressionist landscape, and, in spite of Constable's concern with movement, the whole picture has a feeling of permanence and weight; and I am reminded that Wordsworth, in his Preface of 1802, says that he chose rustic subjects because in them 'the passions of men are incorporated with the beautiful and permanent forms of nature'.

These first impressions I receive from both versions of *The Leaping Horse*, the picture which Constable exhibited in the Royal Academy in 1825 and the full-sized study for it in the Victoria and Albert Museum. But thenceforward my feelings differ. In the Academy picture I admire the graceful drawing of the trees to the left and the firmly painted distance, with its view of Dedham tower, till recently half-covered by the frame. The horse itself I find rather stodgy, and the osier tree looks like a contrivance; but this may be only hindsight, for I know that when Constable first imagined the scene the tree was in a different place.

In the Victoria and Albert picture, on the other hand, I do not pause to look at details, but am bowled over by the passion and energy of the whole. Everything is done with stormy strokes of the palette knife, so that the surface seems alive; and, when one looks at it closely, the transformation into paint of the thing seen is as inexplicable as in a late Cézanne. "Painting", said Constable, "is for me but another word for feeling." There is no doubt which version of *The Leaping*

Horse communicates his feelings most immediately, and for this reason I have made the Victoria and Albert 'sketch' the subject of this essay, in spite of the greater weight and composure of the final picture.

Given this emphasis on the expression of feeling, which occurs again and again in Constable's letters, why did he find it necessary to make more restrained versions of all his great landscapes? I suppose that the situation grew up almost accidentally. When, after half a lifetime of painting small pictures, he came to attack his first large canvas, he was puzzled how to keep the intensity of his response to nature in a work which would be built up slowly in a studio; and instinctively, almost self-protectively, he adopted the procedure of a full-size sketch. It did not occur to him that this sketch would inevitably become *his* picture, and in fact the earlier 'first versions', even that of *The Hay Wain*, could still be thought of as sketches. But already in *Barges on the Stour* (1822) the first version contains all that Constable had to say, and in *The Leaping Horse* (1824) the word sketch is no longer applicable. The foreground, which in *The Hay Wain* is left vague, is carried almost too far for our modern notions, and every square inch of the canvas has been covered with thick, purposeful paint.

By this time, however, Constable had come to assume that another version was necessary; and so, from a material point of view, it was. The free handling of his exhibited pictures was much criticised, and even his friends asked him to attempt greater finish. They were also distressed by the violence of his expression. As early as 1811 his uncle wrote to him that 'cheerfulness is wanted in your landscapes. They are tinctured with a sombre darkness.' One side of Constable's character responded to this advice. He consciously admired the benevolent aspects of nature, and wished to render them as realistically as possible, even although this meant altering the stormy colour and agitated scrawl of the palette knife of his first responses into peaceful green and graceful strokes of the brush.

112

38 CONSTABLE: Detail of the barge, from the *Study for The Leaping Horse*

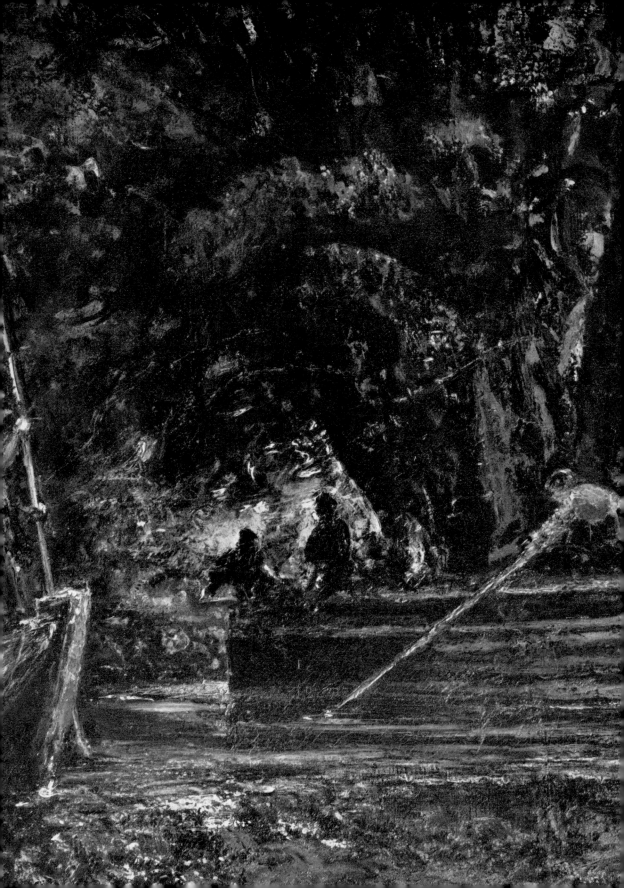

Constable

We can now see that there were two Constables, the reassuring English yeoman whose pictures are used as advertisements for breweries and insurance companies, and the proud, touchy melancholic, for whom only trees and children were tolerable company. Nothing in his early life accounts for the second Constable. He was born in 1776, the son of a prosperous miller, and was brought up in a large red brick house of the kind that no one can afford to live in any longer. In his youth he was free to wander in the fields, bathe in the Stour and sleep in the shadow of haycocks, and he wrote afterwards, 'These scenes made me a painter (and I am grateful)'.

He had the slowest start of any painter before the time of Grandma Moses. In 1802 his first picture was exhibited in the Academy. It was a view of Dedham, small, shy and self-effacing, and naturally attracted no comment. In the same year Turner was made a full Academician. For the next twelve years Constable maintained a precarious existence by painting, and even copying, portraits. There is an almost total gap between his small oil sketches, which are works of genius, and his finished pictures, which are inhibited and dull. For ten years he carried on a frustrated love affair with a lady who might have been the heroine of *Mansfield Park*. In 1816 they were married.

For most painters this biographical detail would be almost irrelevant, but for Constable it is crucial, for his powers could function only against a background of family affection. He longed to embrace nature as a harmony of procreation and growth, and this had first of all to be enacted in his own life. Mrs Constable has come down to us as a prim, plaintive invalid, but she had seven children, and the span of Constable's inspiration was bounded by the years of his married life. There was no sudden change of style. He continued to work on motives that he had discovered before 1816. But he gained that physical confidence which, as he says more than once, is the essential of landscape painting. This not only strengthened his response to nature, but gave him the vitality to cover a six-foot canvas with gouts of paint, in which the force of the first sensation is never lost.

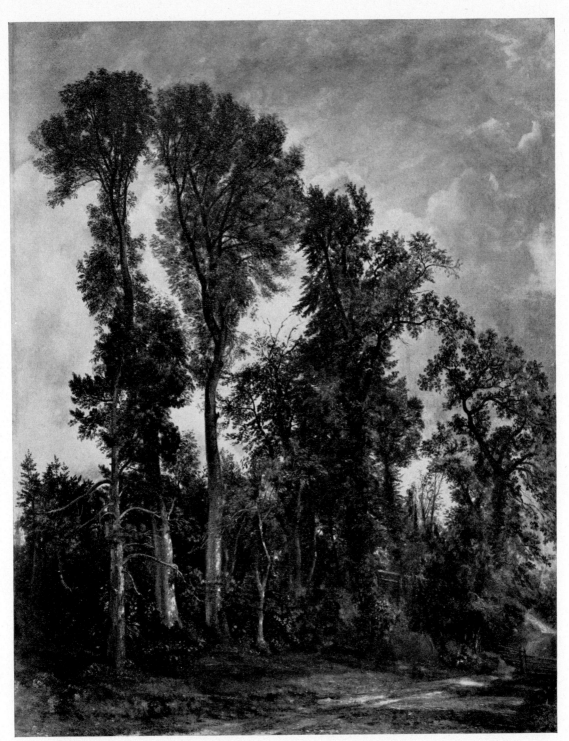

39 CONSTABLE: *Trees near Hampstead Church, 1821.* London, Victoria and Albert Museum

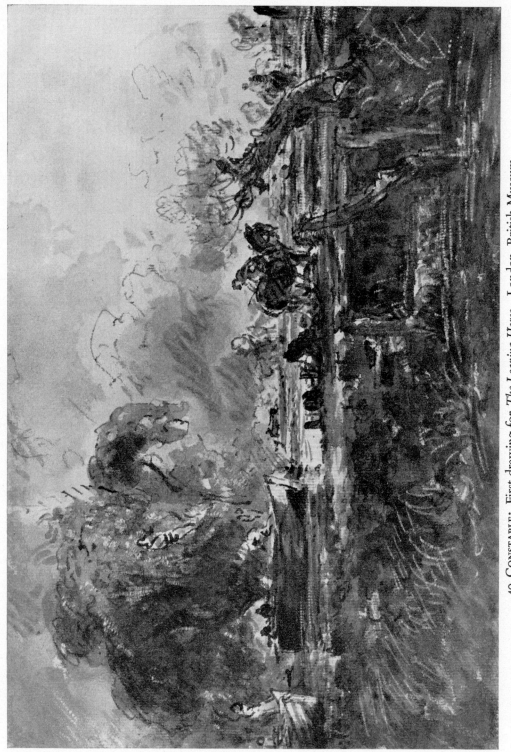

40 CONSTABLE: First drawing for *The Leaping Horse.* London, British Museum

Study for The Leaping Horse

The Leaping Horse was painted towards the end of this blissful decade. His energy and control of the medium are at their height; the long struggle with natural appearances seems to have ended in mastery. But the dark colours, inky blue, grey and rust, without a spot of peaceful green, show that the demon of melancholy was still lying in wait. In 1828, when his wife died, it was released, and sent his palette knife plunging over the surface of *Hadleigh Castle*. "Every gleam of sunshine is blighted for me," he said. "Tempest on tempest rolls—still, the darkness is majestic."

And so it is in *Salisbury Cathedral from the Meadows* (1830), one of the most moving of all his works; also "the trees and clouds still seem to ask me to try to do something like them", and there are sketches from nature done in the 'thirties in which he achieves the rapturous self-identification of his harmonious years. But in the exhibited pictures loss of confidence showed itself, as it usually does in mannerism. The *Valley Farm* is as unnatural as a late Pontormo, and almost as tortured as a Van Gogh.

Constable was fortunate in having a friend to write his biography, and although Leslie certainly over-emphasised the more agreeable features of his subject, and omitted from his letters many of the withering comments on his fellow-artists which made him so little loved in academic circles, the *Life* contains many phrases and anecdotes which throw light on his paintings. *The Leaping Horse* reminds me of one of these, how 'the amiable, but eccentric Blake', as Leslie calls him, looking at Constable's pencil sketches said, "This is not drawing but inspiration". To which Constable replied with characteristic snappiness, "I never knew it before. I took it for a drawing." In fact Blake was correct. Although Constable was an insatiable observer of nature, his great compositions all came to his mind complete, as clearly as the visions of Blake. They appear first as small, precise drawings in pen or pencil, which are scarcely altered in the final picture, and the studies which follow are intended more to explore the expressive possibilities of this first idea than to modify its structure.

117

Constable

The subject of *The Leaping Horse*, a barge emerging from the shadows of trees, balanced by a horse and a sluice-gate, was not new in Constable's work; the new and dominating motive was the placing of these incidents on a high stage, so that they achieve the dignity of monumental sculpture. It is one of those ideas which work better in a sketch than in a finished picture because of the large area of foreground. In a drawing this can be indicated by scribbles; in a painting it must be furnished with vegetation. As a result the drawings for *The Leaping Horse* show the incident placed higher up in the picture space than does the finished painting, and yet the whole foreground is subservient to the movement. The first drawing in the British Museum has a unity which he never quite recaptured. But it differs from the picture in one vital particular: the horse does not leap. It stands patiently, its rider looking back at the barge, bending in conformity with the rhythm of an osier on the right, and a cloud which stretches across to the main group of trees. The motive of *The Leaping Horse* first appears in a splendid drawing in chalk and sepia, and immediately the whole design takes on a more dramatic rhythm. The clouds rise, the batten of wood supporting the sluice is given an upward thrust, the barge is more forcefully propelled and the osier on the right straightens its back.

In all forms of human composition, from family life onwards, there are certain minor characters who come to dominate the scene by their intractability. Such was the osier in *The Leaping Horse*. When it rose in sympathy with the horse it became too important. But when, in the Victoria and Albert picture, Constable put it back exactly as it was in the first sketch, it constrained the horse's movement. It was still to the right when the final version was sent to the Academy in 1825, and only after the picture had returned to him unsold was it fitted into its present central position. But this led to further trouble, because the space between the trees and the horse had already been filled in by our anticipation of the barge's movement, and when the osier appeared, the barge had to be slowed down. The punting man

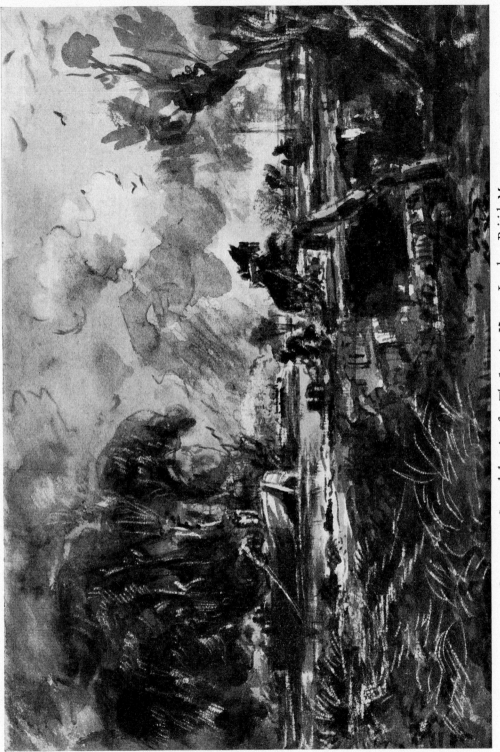

41 CONSTABLE: Second drawing for *The Leaping Horse*. London, British Museum

is removed, the diagonal of his pole replaced by a limp sail; and the far side of the barge's prow is painted out, so that it no longer comes forward out of the tunnel of trees, but lies almost parallel with the river bank. This static condition is confirmed by a vertical mast; and the osier's first ascending movement, which still haunts him, is given to a beautifully designed tree.

As usual there are losses and gains. The urgency of the composition has been lost, and the left-hand group is slightly academic; on the other hand the removal of that obstreperous osier has cleared up the right-hand side, and we see that nothing more was needed to balance the movement of the horse than the diagonal wooden buttress of the sluice-gate.

Should the horse ever have leapt? Constable's first drawing was what Blake called 'inspiration', and it was perilous to add that incident. Yet it was a stroke of genius. He must have recognised unconsciously that the horse on its high, architectural base was like an equestrian monument; and so in the final version this rustic episode takes its place at the end of that long line of heroic commanders on prancing horses which began with Leonardo da Vinci's monument to Francesco Sforza. Constable often said that he wanted to give landscape the status of 'historical painting'. To do so the drama of light and shade was not quite enough. Romantic landscape, like all romantic art, required a hero, even an inanimate hero, like the spire of Salisbury Cathedral, which could resist the power of the elements or take action contrary to the clouds. When the horse conformed to the composition it was undramatic. When it leapt it became the hero, and gave its title to one of the greatest English pictures.

Study for The Leaping Horse, by John Constable (1776–1837), is in oils on canvas, $49\frac{1}{2}'' \times 72\frac{3}{4}''$ (1.257 × 1.846 m.). It was painted in 1824–1825 and is a large preliminary study for the picture exhibited in the Royal Academy in 1825 with the title *Dedham Lock*. After Constable's death it was sold at Foster's in May 1838 and bought by Mr Archbutt; it later passed to Mr Vaughan, who bequeathed it to the Victoria and Albert Museum in 1900.

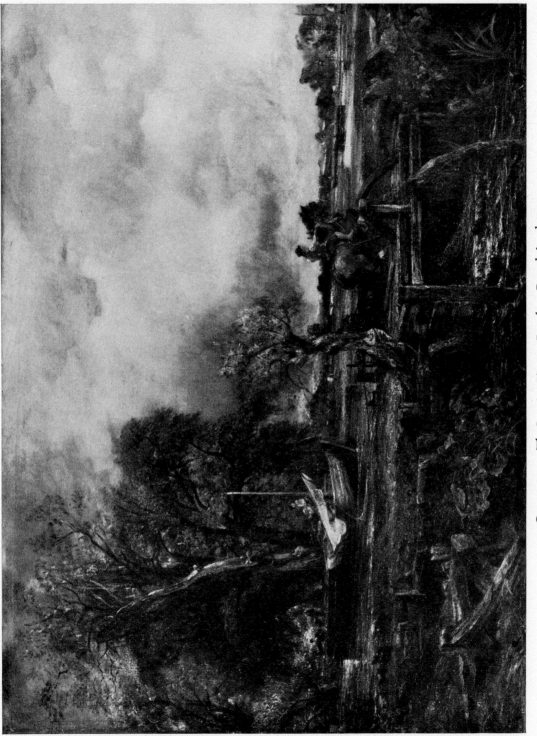

42 CONSTABLE: *The Leaping Horse.* London, Royal Academy

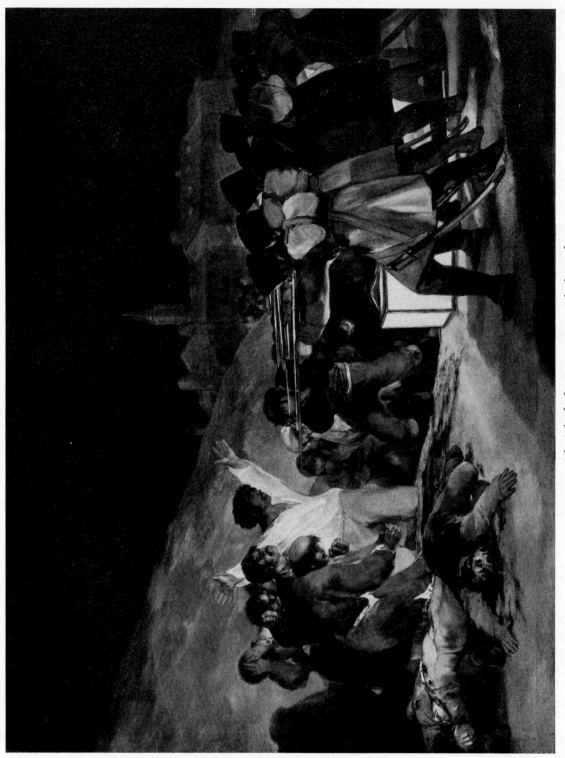

43 GOYA: *The Third of May, 1808.* Madrid, Prado

GOYA

The Third of May, 1808

CAN THE INSTANTANEOUS become permanent ? Can a flash be prolonged without losing its intensity ? Can the shock of a sudden revelation survive the mechanics by which a big picture is composed ? Almost the only affirmative answer in painting is Goya's picture of a firing squad, known as *The Third of May*. Coming on it in the Prado with one's head full of Titian, Velasquez and Rubens, it deals a knock-out blow. One suddenly realises how much rhetoric even the greatest painters have employed in their efforts to make us believe in their subjects. Delacroix's *Massacre at Chios*, for example: it was painted ten years later than *The Third of May*, and it might have been painted two hundred years earlier. The figures are sincerely expressive of Delacroix's feelings, both as a man and a painter. They are pathetic, but they are posed. We can imagine the admirable studies that preceded them. With Goya we do not think of the studio or even of the artist at work. We think only of the event.

Does this imply that *The Third of May* is a kind of superior journalism, the record of an incident in which depth of focus is sacrificed to an immediate effect. I am ashamed to say that I once thought so; but the longer I look at this extraordinary picture and at Goya's other works, the more clearly I recognise that I was mistaken.

It hangs in the next room to his tapestry designs, where, at first sight, he seems to be working, with unusual skill, in the accepted manner of rococo painting. There are the picnics and parasols and open-air markets which one finds in the frescoes of Gian Domenico Tiepolo in the Villa Valmarana. But as one looks at them more closely

123

the warm air of eighteenth-century optimism grows decidedly chillier. One discovers heads and gestures of maniac intensity, glances of pure malevolence or sinister stupidity. Four women are tossing a dummy in a blanket, a charming theme for Fragonard; but the equivocal limpness of the manikin and the witch-like glee of the central woman already foreshadow the *Caprichos*.

The tapestry designs show another of Goya's characteristics: his unequalled gift for memorising movement. The saying attributed to both Tintoretto and Delacroix, that if you cannot draw a man falling from a third storey window you will never be able to paint a great composition, is eminently true of Goya. And this power of concentrating his whole physical being on a split second of vision was developed by an accident. In 1792 Goya had a serious illness which left him totally deaf: not just hard of hearing like Reynolds, or progressively bothered by interior buzzings like Beethoven, but stone deaf. Gesture and facial expression, when they are seen without the accompanying sound, become unnaturally vivid; that is an experience we can have any day by turning down the sound of television. Goya had it for the rest of his life. The crowds in the Puerto del Sol were silent to him; he could not have heard the firing squads on the third of May. Every experience reached him through the eye alone.

But he was not simply a high-speed camera. He drew from memory, and as he thought about a scene its essence suddenly took shape in his mind's eye as a pattern of dark and light. In his first rough drawings these black and white blots tell the story long before any detail is defined. After his illness the stories are for the most part gruesome and the dialogue of light and dark is correspondingly sinister. Even when nothing particularly alarming is going on, as in the plate of the *Caprichos* entitled 'Mala Noche', we are frightened by the shape of a fluttering scarf. Goya himself does not seem to have been altogether aware of how these shadows speak to us, for the explanatory notes he wrote on a set of the *Caprichos* are perfectly banal, and if the plates did no more than illustrate these texts they would not frighten us at all.

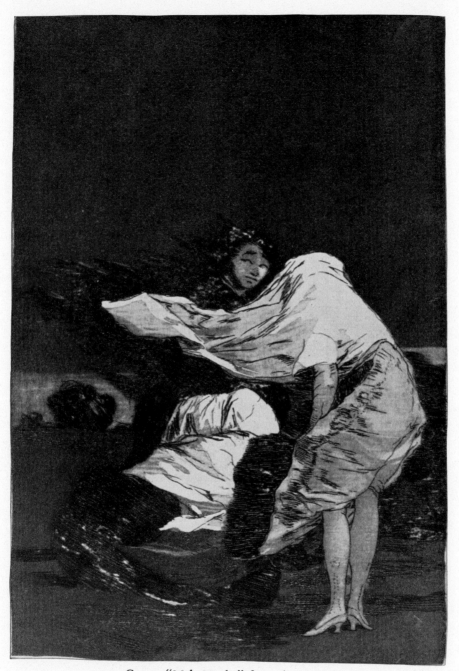

44 GOYA: "Mala Noche" from the *Caprichos*

Goya

Whereas they are a series of archetypal nightmares, in which the shadows on the nursery wall do really turn into a man hanging on a gibbet or a congress of goblins:

The first crisis of Goya's life was his illness in 1792; the second was the occupation of Madrid by Napoleon's armies in 1808. Goya was in an uneasy position. He had been in favour of the revolution, he had no reason to think highly of his royal masters and he wanted to keep his position as official painter, whoever was in power; so at first he made friends with the invaders. But he soon learnt what an army of occupation means. On the second of May the Spaniards had shown a little fight. There was a riot in the Puerto del Sol; some officers fired a few shots from a gun on a hill above the town. Murat ordered his Egyptian cavalry to cut down the crowds and the following night set up a firing squad to shoot anyone who happened to be available. It was the beginning of a series of brutalities which stamped themselves on Goya's mind and which he set down in the most horrifying record of war ever made in any medium.

The French were finally expelled, and in February 1814 Goya asked the provisional government for an opportunity to 'perpetuate by the means of his brush the most notable and heroic actions of our glorious insurrection against the Tyrant of Europe'. His proposal was accepted and he set to work on the episodes of the second and third of May, the Mamelukes in the Puerto del Sol and the firing squad the following night. Both pictures are now in the Prado. The first is an artistic failure. Perhaps he could not shake off the memory of similar compositions by Rubens: but for whatever reasons, the black and white flash has not taken place; the horses are static, the figures posed. The second is perhaps the greatest picture he ever painted.

So, far from being a glorified press photograph, *The Third of May* was painted as a commission six years after the event and it is certain that Goya had not been an eyewitness. It is not the record of a single episode, but a grim reflection on the whole nature of power. Goya was born in the age of reason and after his illness he was obsessed

by all that could happen to humanity when reason lost control. In *The Third of May* he shows one aspect of the irrational, the predetermined brutality of men in uniform. By a stroke of genius he has contrasted the fierce repetition of the soldiers' attitudes and the steely line of their rifles, with the crumbling irregularity of their target. As I look at the firing squad I remember that artists have been symbolising merciless conformity by this kind of repetition since the very beginning of art. One finds it in the bowmen on Egyptian reliefs, in the warriors of Assur-Nasir-Pal, in the repeated shields of the giants on the Siphnian Treasury at Delphi. In all these monuments power is conveyed by abstract shapes. But the victims of power are not abstract. They are as shapeless and pathetic as old sacks; they are huddled together like animals. In the face of Murat's firing squad they cover their eyes, or clasp their hands in prayer. And in the middle a man with a dark face throws up his arms, so that his death is a sort of crucifixion. His white shirt, laid open to the rifles, is the flash of inspiration which has ignited the whole design.

In fact the scene is lit by the lantern on the ground, a hard white cube in contrast to the tattered shape of the white shirt. This concentration of light, coming from low down, gives the feeling of a scene on the stage; and the buildings against the dark sky remind me of a back-cloth. And yet the picture is far from being theatrical in the sense of unreal, for at no point has Goya forced or over-emphasised a gesture. Even the purposeful repetition of the soldiers' movement is not formalised, as it would have been in official decorative art, and the hard shapes of their helmets seem to deliver their blows irregularly.

The Third of May is a work of the imagination. Goya is sometimes spoken of as a realist, but if the word means anything, it means a man who paints what he can see and only what he can see. By a curious chance there exists a sort of version of *The Third of May* painted by the perfect realist, Manet's *Execution of the Emperor Maximilian*. Manet had frequently poured scorn on subjects of this kind. "The reconstruction of a historic scene. How absurd ! Quelle bonne plaisanterie."

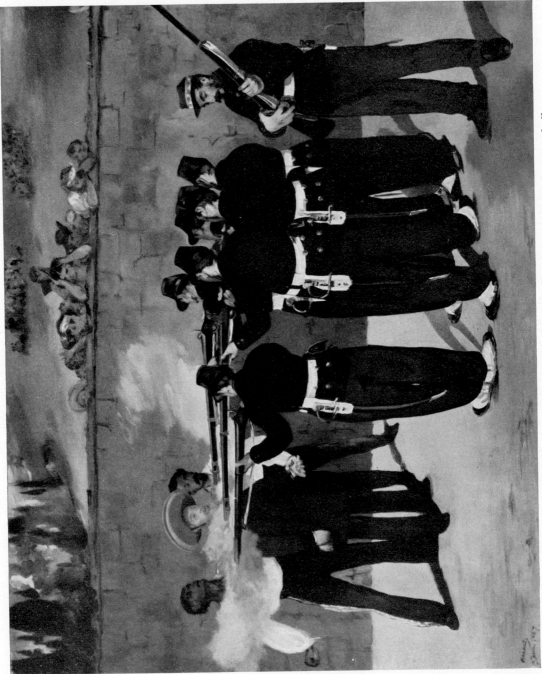

45 MANET: *Execution of the Emperor Maximilian.* Mannheim, Städtische Kunsthalle

The Third of May, 1808

However, the tragic end of Maximilian had stirred his sympathies, and immediately on hearing of the event he procured a photograph of it and set to work on a picture for the Salon of 1867. He had an unbounded admiration for Goya and I think that there can be no reasonable doubt that he had seen *The Third of May* in the cellars of the Prado during his short visit to Madrid in 1865; the man on the left in the white shirt puts the similarity beyond coincidence. But how little he has recognised, or at least tried to emulate, the point of Goya's picture. An historic event painted in this flat and inexpressive way really is as pointless as Manet maintained it to be. Perhaps that is why he cut up his large version (the smaller study survives), so that the fragment of a soldier examining his rifle might be appreciated for what it is, an admirable study of a model. Manet, who was usually well aware of what he was doing, must have realised that by turning this figure away from the central focus of the scene he would lose the dramatic concentration which animates the Goya. Why did he do it? Was the bland indifference of this rifleman intended as a kind of irony? I doubt it. More likely he thought the pose pictorially self-sufficient.

Manet was a great painter, combining a selective eye and a tactful hand with admirable honesty of purpose; but he lacked the consciousness of tragic humanity. It is revealing that what had moved him was the execution of an Emperor. Marxist terminology usually obstructs criticism, but in looking at Manet's painting, I cannot dismiss the word bourgeois. His eye was free, but his mind was dominated by the values of upper middle-class Parisian society. Whereas Goya, in spite of his lifelong employment by the Court, remained a revolutionary. He hated authority in any form: priests, soldiers, officials; and he knew that, given the chance, they would exploit the helpless and keep them down by force. It is this feeling of indignation which gives symbolic force to the man in the white shirt, to the pitiful body sprawling on the ground in a welter of blood, and to the batches of fresh victims who are being driven forward out of the darkness.

Goya

This is the first great picture which can be called revolutionary in every sense of the word—in style, in subject and in intention; and it should be a model for the socialist and revolutionary painting of the present day. Unfortunately social indignation, like other abstract emotions, is not a natural generator of art; also Goya's combination of gifts has proved to be very rare. Almost all the painters who have treated such themes have been illustrators first and artists second. Instead of allowing their feelings about an event to form a corresponding pictorial symbol in their minds, they have tried to reconstruct events, as remembered by witnesses, according to pictorial possibilities. The result is an accumulation of formulas. But in *The Third of May* not a single stroke is done according to formula. At every point Goya's flash-lit eye and his responsive hand have been at one with his indignation.

The Third of May in Madrid, 1808: the Firing Squad before the house of Prince Pio, by Francisco de Goya (1746–1828), is in oils on canvas, $104\frac{3}{4}'' \times 136''$ (2.66 × 3.45 m.). It was painted in 1814, together with a companion piece of the same size representing the riots in the Puerto del Sol. Goya was paid 1,500 *reals* for the two. They were deposited in the Prado in 1834, but were not mentioned in a catalogue till 1872.

46 GOYA: Detail from *The Third of May*

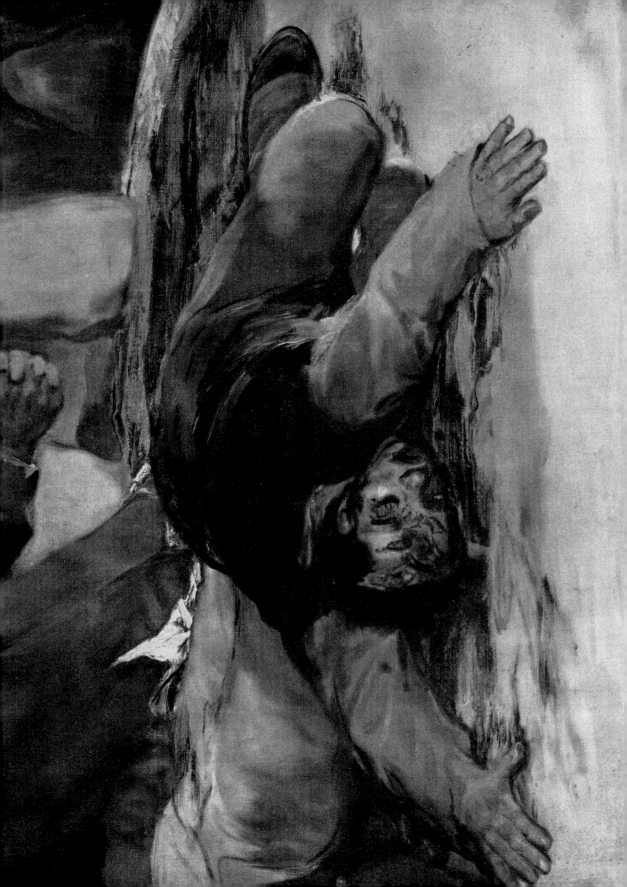

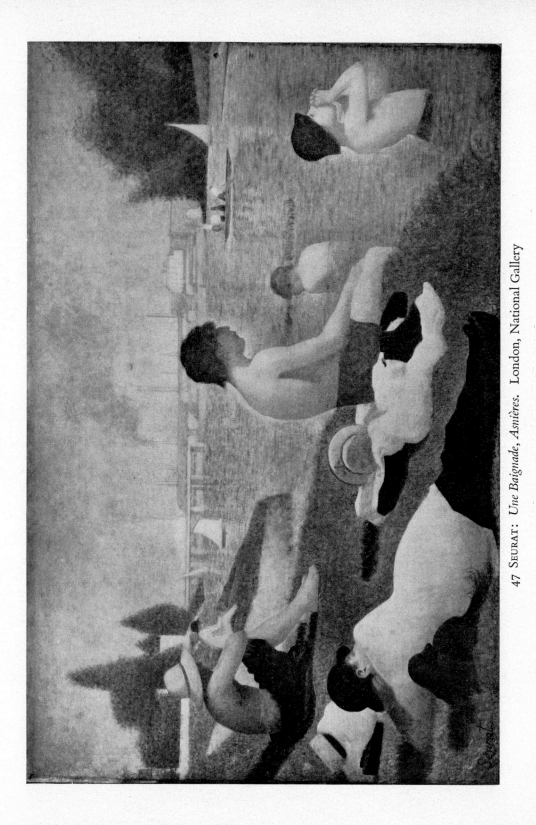

47 SEURAT: *Une Baignade, Asnières.* London, National Gallery

SEURAT

Une Baignade, Asnières

THERE ARE MOMENTS on hot summer days when we are pre-
pared for a miracle. The stillness and the gently vibrating haze
give to our perceptions a kind of finality, and we wait listening
for some cosmic hum to enchant, like Papageno's bells, the uncouth
shapes and colours which surround us, so that they all dance to the same
tune and finally come to rest in a harmonious order. In life the miracle
doesn't happen, and it is rare enough in art, because great painters have
usually created imaginary worlds, outside the range of our ordinary
visual experience. But it happens in Seurat's *Baignade*. As I catch
sight of this large canvas at the end of the gallery, framed by a door so
that the illusion of reality is increased, I feel that the haze and stillness
of summer have at last fulfilled their promise. Time has stopped,
everything has become its proper shape, and every shape is in its proper
place.

It is this aspect of the *Baignade* that first attracts my attention. I
start by looking at the heap of clothes and boots beside the central
figure, and am fascinated by the way in which these commonplace
objects have been given a monumental character, and have been set
off against one another, light against dark, so that each area has its full
value both as tone and silhouette. The same is true of the bowler hats,
panamas and wrinkled trousers which proceed in orderly sequence up
the left-hand side of the canvas and end in an austere construction of
walls and trees. At this point my eye has penetrated into the distance,
and once there it moves with exhilaration through the shimmering
summer light till it is arrested by the dark head of the principal figure.

133

Seurat

However often I look at the *Baignade* this figure gives me a slight shock of surprise. How did Seurat come to put this monolith, as grave and simple as one of the ancients of Arezzo, in front of an Impressionist landscape ? It is the kind of synthesis which ambitious young painters often set themselves and seldom achieve. Everyone knows that Tintoretto wrote on his studio walls 'the drawing of Michelangelo and the colour of Titian'. He was hardly more ambitious than the young man of twenty-four who set out to reconcile an analysis of vibrating light with the calculated grandeur of a fifteenth-century fresco.

Seurat was born in 1859 and at the age of eighteen became a student at the Ecole des Beaux-Arts in Paris. His teacher was Henri Lehmann, one of Ingres' best pupils, and his earliest surviving works are copies of Ingres, Holbein and other masters of precision. He was a serious, diligent young man, but when, in 1879, he left the Beaux-Arts he had risen only to forty-seventh place, and no one prophesied for him a brilliant future.

These were the creative years of Impressionism, but there is no evidence that the young Seurat showed the faintest interest in open-air painting till after he had spent his year of military service at Brest; and it is characteristic of him that the revelation of light should have come to him as he gazed on the sea during the hours of sentry duty. The solitude, the patience, the immobility and the discipline allowed something in his nature to grow which would have shrunk in the cheerful picnics of Monet, Renoir and their friends at Argenteuil. He saw men not as sunny and convivial presences, but as lonely silhouettes against the horizon; and I believe that this determined his style when he was once more free to be a painter. A complete change was necessary. As a disciple of Ingres he had learned to turn perceptions into line. He now set about a series of drawings in which there should be no lines at all, but only areas of tone. It was one of those moments of revelation when an inarticulate man suddenly finds his own language. Through the medium of *conté* crayon on rough-grained paper Seurat

48 SEURAT: Drawing for the principle figure in *Une Baignade*. S. A. Morrison Collection

felt able to simplify the most complex subjects and give monumental stillness to the most ephemeral impressions—his father eating dinner or the last seconds of a winter sunset. At the same time he painted in the suburbs of Paris a few prosaic landscapes in which the element of design was achieved by walls and windows and factory chimneys arranged with austere frontality. Like his drawings, they depended on juxtapositions of tone and were executed with thick square brush strokes in a few simple earth colours. On the basis of these two exercises he set to work, calmly and methodically, to paint a masterpiece.

All this we can learn from the books on Seurat, and it goes some way towards making the *Baignade* comprehensible. But as we contemplate these large forms arranged so majestically in a single plane, we cannot fail to think of fifteenth-century Italian frescoes and I used to spend a lot of time wondering how Seurat, who had never been to Italy, could have achieved this strange similarity with Piero della Francesca. Of course, coincidences exist in the history of art, but historians do not like them, and I confess to a feeling of relief when I read a footnote in Professor Longhi's book on Piero to the effect that in 1874 copies of the Arezzo frescoes were placed in the chapel of the Ecole des Beaux-Arts by the order of that exceptionally intelligent professor, Charles Blanc. There they are still, together with some excellent copies of Giotto, and no doubt Seurat, who admired Charles Blanc, had been encouraged to look in this unfashionable quarter for a solution to his problems.

The remarkable thing is how completely he has assimilated this influence to contemporary vision. In the 1880's Puvis de Chavannes was perhaps the only living painter who commanded the respect of both academic and revolutionary painters, and a young man anxious to achieve the qualities of a fifteenth-century fresco would normally have turned to Puvis' tasteful and serious translations. But at this date Seurat still believed in the faith of the Impressionists, the primacy of visual sensations, and he based his great construction on small colour

49 SEURAT: Study for *Une Baignade*. Christabel, Lady Aberconway Collection

notes painted on the spot. Thirteen of these survive, and show us that the root idea of the *Baignade* was the interplay of black-and-white units in the foreground, a sparkling expanse of river, and, in the distance, the severe lines of the railway bridge and the factory chimneys.

In the earliest sketches the foreground units are horses, black and white contrasted, as in Piero's fresco; but gradually the horses recede into the background and finally disappear, their place being taken by men in black waistcoats and white shirt-sleeves. It was a change of more than pictorial importance; for it meant that a motive with romantic overtones was discarded in favour of a normal episode in popular life. Even in the penultimate sketch the boy seated on the left was clothed and wore a bowler hat, but the blacks outbalanced the whites, and Seurat finally hit on the ingenious solution of dressing the figure in a white vest, but situating him in a patch of shadow, so that he could reflect the surrounding colour.

137

Seurat

When all the protagonists had taken their places on the lighted stage of his memory, he made studies in *conté* crayon from nude models posed in his studio. As a result he was able to give these simple masses a remarkable suggestion of relief, all except the man lying in the foreground who, in order not to create a new focal plane, was left as trite as a tailor's dummy.

He sent his picture to the Salon of 1884 and, inevitably, it was refused. Circumstances had changed since Titian painted for the Palace of Mantua and Velasquez for the Alcazar, and the *Baignade* was first seen in Barrack 'B' of the Tuileries, which the Artistes Indépendants had hired for their exhibition. It was not thought worthy of a place in the proper rooms, but was hung in the buffet. Even so it did not go unnoticed, and one of Seurat's fellow-painters, Paul Signac, was so moved by it that he became thenceforward Seurat's indefatigable propagandist. "The understanding of the laws of contrast," he said of it, "the methodical separation of elements and their proper balances and proportion give this canvas its perfect harmony." With this early and excellent criticism of the *Baignade* in my mind, I return to look at it more closely.

My first thought is how little can one tell about any picture painted after 1870 from a black-and-white reproduction. The *Baignade* is conceived in colour; for example, the clothes and boots, which look as black as truffles in a photograph, are actually horse-chestnut colour, and are quite fully modelled. And, of course, we cannot guess that the boy in the panama is coloured like a prism. As with Delacroix, one must look closely at the *Baignade* to realise how colouristic it is, and in fact we know that Seurat himself had looked very attentively at Delacroix's decorations in St-Sulpice and had learnt from them how to associate complementary colours so that they add to each other's resonance. But although the influence of Delacroix has been much cracked up, the general tonality of the *Baignade* is entirely different. Almost any detail cut out of the background would pass as an impressionist picture, less brilliant than Renoir's *La Yole* (which

138

had been painted in the same place four years earlier), and more precise than Monet's *Courbevoie*. This newly won mastery of light, with all that it implies of technical skill, Seurat has taken in his stride while pursuing a different end.

Finally my eye passes down to the boy hallo-ing. He is the most poetic image left in the *Baignade*, and I have a feeling that some day I shall find his prototype in antique painting. But for the moment my attention is absorbed by the little dots of blue and orange with which Seurat has modelled his cap. I see that there are similar dots of pure colour in the water surrounding him, and I begin to find them scattered all over the right-hand side of the picture and even on the waist of the principal figure. Seurat adopted this method of painting in dots of spectrum colour a year or so after exhibiting the *Baignade*, so he must have added these touches later, perhaps when it came back from exhibition in New York in 1886; and this leads me to meditate on the strange evolution through which he was to pass in the remaining seven years of his life, and to wonder how much was gained and lost when the poet of *Une Baignade* became the theorist of *Le Cirque*.

Perhaps it was inevitable. The extraordinary firmness of will with which Seurat had attained his end in his first large picture was almost bound to mean the suppression of certain poetic impulses which are of their nature disorderly and vague. An admirable method can easily become an end in itself. Seurat was, by all accounts, the perfect type of Cartesian Frenchman for whom tidiness is the first of all virtues.

If he had lived till 1940, as he might easily have done, for he was strong and abstemious, instead of dying of diphtheria in 1891, would he not have anticipated the purest phase of cubism? Compositions in the manner of Mondrian, carried out with Seurat's distinction of mind and eye, would have provided the seeker after Platonic beauty with something very near to his ideal. Some of this is implicit in Seurat's later work, and gives us a peculiar and rarefied pleasure. But already in the *Parade* the sacrifices involved have been very great. His sensitive response to things seen has been suppressed in favour of quasi-symbolic

V SEURAT: Boy hallo-ing, from *Une Baignade*

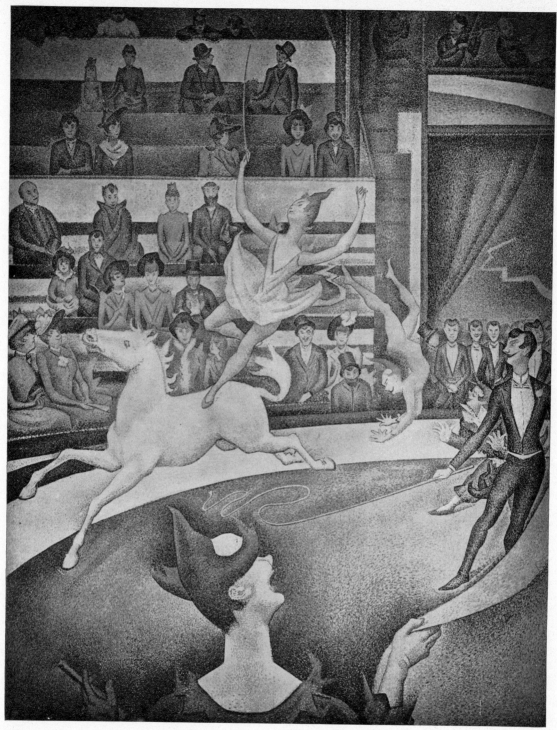

50 SEURAT: *Le Cirque*. Paris, Louvre

Une Baignade, Asnières

shapes, diagrammatically gay or sad. His gift of seeing masses of tone in a happy relation to one another has been lost in pursuit of a system of colour which impressed his contemporaries as scientific, but which turns out in retrospect to have been as arbitrary and self-imposed as the rules of chess. All this was a deliberate sacrifice, and was perhaps due as much to moral as to intellectual scruples. It was Cistercian rather than Cartesian. Much as I admire this feeling of total obligation, I am unregenerate enough to prefer an art from which the first impulses of perception, sympathy and delight have not been altogether removed, and so I return gratefully from Seurat's circus pictures, hieratic, angular and unreal as the mosaics of Torcello, to the harmonious democracy of *Une Baignade*.

Une Baignade, Asnières, by Georges Seurat (1859–1891), is in oil on canvas, measuring $71\frac{3}{4}''$ $\times 144\frac{1}{4}''$ (1.82 × 3.66 m.). It was begun in the summer of 1883, and painted slowly. Thirteen preparatory studies for it and ten drawings were discovered in Seurat's studio after his death. It was sent in to the Salon in the spring of 1884 and rejected. From May to July it was exhibited with the *Groupe des Artistes Indépendants*, in a modern structure in the Tuileries. In 1886 it was sent to New York by Durand Ruel for an exhibition in the National Academy of Design called *Oils and Pastels by the Impressionists of Paris*. It was unsold at his death, and later purchased from his family by Félix Fénéon. The Trustees of the Courtauld Fund bought it for the Tate Gallery in 1924.

The scene is a bend of the Seine near an industrial suburb of Paris named Asnières. In the background is the bridge of Courbevoie, frequently painted by Monet and Renoir. To the right is the island of the Grand Jatte, which Seurat was to make the setting for his second great picture. The fact that Seurat added some touches to the picture after its return from America is mentioned in Signac's diary for December 29, 1894.

141

51 Turner: *The Snowstorm.* London, National Gallery

TURNER

The Snowstorm

MY FIRST EMOTION is sharpened by amazement. There is
nothing else remotely like it in European art, except, of
course, other pictures by Turner, and I can understand why,
till recently, critics brought up in the classical tradition were unwilling
to accept such a freak. Not only is the subject exceptional, but the
whole rhythmic organisation is outside the accepted modulus of
European landscape painting. We have been brought up to expect
inside a frame a certain degree of balance and stability. But in Turner's
Snowstorm nothing comes to rest. The swathes of snow and water
swing about in a wholly unpredictable manner, and their impetus is
deflected by contrary movements of spray and mysterious striations of
light. To look at them for long is an uncomfortable, even an exhaust-
ing, experience.

Of course other painters have attempted to render the movement
of rain and sea; but rough sea usually has a theatrical pasteboard look,
and when it comes to rain even the greatest artists have found it neces-
sary to formalise what they cannot accurately describe. Leonardo da
Vinci comes nearest to Turner in his desire to render elemental power.
But as he contemplated the movement of water (and no man has looked
at it more searchingly) he fastened on those rhythms which had some
relation to geometry. In his drawings at Windsor of a deluge the
curling loops of rain end in circular vortices equivalent to the logarith-
mic spirals of a shell. These are the highly intellectual forms which
his hand traced, consciously or unconsciously, when he came to repre-
sent universal destruction. Similarly, in Chinese art, the movement of

52 LEONARDO DA VINCI: Deluge drawing. Windsor, Royal Library

waves and rain nourishes the ancient tradition of cursive ornament, and clouds are formalised till they become the commonest *motif* of decoration. Between the Dragon scroll at Boston and Hokusai's *Views of Fuji* oriental painting is full of rough seas and threatening skies; but how delightfully harmless they are. Perfect taste has cast out fear.

Looking again at the *Snowstorm*, with these decorative deluges in mind, I am astonished by the way in which Turner has accepted the apparent disorder of nature, but I do not question that his version of the subject is correct. It has the visual tremor of an immediate experience. The chaos of a stormy sea is portrayed as accurately as if it were a bunch of flowers.

144

The Snowstorm

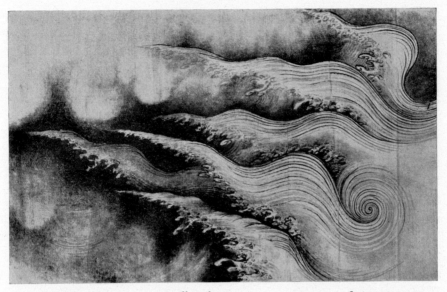

53 CHINESE: Dragon Scroll 13th-C.? Boston, Museum of Fine Art

Turner, who was well aware of the licence he often took with nature, was unusually insistent on the truth of this particular scene. In the Royal Academy catalogue of 1842 the entry reads 'Snowstorm— steam-boat off a harbour's mouth making signals in shallow water, and going by the lead. The author was in this storm on the night the *Ariel* left Harwich.' There were no quotations from Byron or 'The Fallacies of Hope'. And when the Rev. Mr Kingsley told Turner that his mother liked the picture, Turner said, "I only painted it because I wished to show what such a scene was like; I got the sailors to lash me to the mast to observe it; I was lashed for four hours and did not expect to escape, but I felt bound to record it if I did. No one has any business to like it."

But of course the *Snowstorm* is very far from rapportage. It is the essence of all that Turner had discovered about himself and his art during forty years of practice. In 1802 the Peace of Amiens had given him his first opportunity to travel on the continent and visit the Alps,

and in his drawings of the source of the Arveron and the falls of Reichenbach he suggests for the first time how the power of nature would force him into a new means of expression. At this time, and for some years to come, he was still engaged in an imaginary competition with his predecessors in the art of landscape painting. But however hard he tries to build his designs in the manner of Claude and Poussin, they will not settle down. They rock and wobble and go off at tangents and contradict themselves in a wholly unclassical manner. And underlying many of them is a curious movement, half-way between the fling of a lasso and the cross-section of some hard-pressed rock, a movement which has no ready assonance in geometry, but which, once we recognise it, we re-discover everywhere in nature.

This is the rhythm of his first great storm at sea, the *Shipwreck* of 1805, which was also painted from personal experience. And how superbly it renders the destructive power and weight of the waves. What more can painting do with that particular subject? The unforeseeable answer is the *Snowstorm*.

When I look back at it across the gallery, with Turner's dark, early sea-pieces in mind, I no longer think about its design, but about its colour; and I see that the dramatic effect of light is not achieved by contrast of tone (as it is in the *Shipwreck*) but by a most subtle alternation of colour. As a result oil paint achieves a new consistency, an iridescence, which is more like that of some living thing—in this case the flower of an iris—than a painted simulacrum. The surface of a late Turner is made up of gradations so fine and flecks of colour so inexplicable that we are reminded, whatever the subject, of flowers and sunset skies. To substitute colour for tone as a means of rendering enlightened space could not be achieved by mere observation: it was a major feat of pictorial intelligence and involved Turner in a long struggle. One can follow some of his experiments in his sketch books, where bands and blocks of colour are set down side by side to see how they influence each other, with an effect like the canvases of some modern American painters, pleasantly reduced in scale. At the same

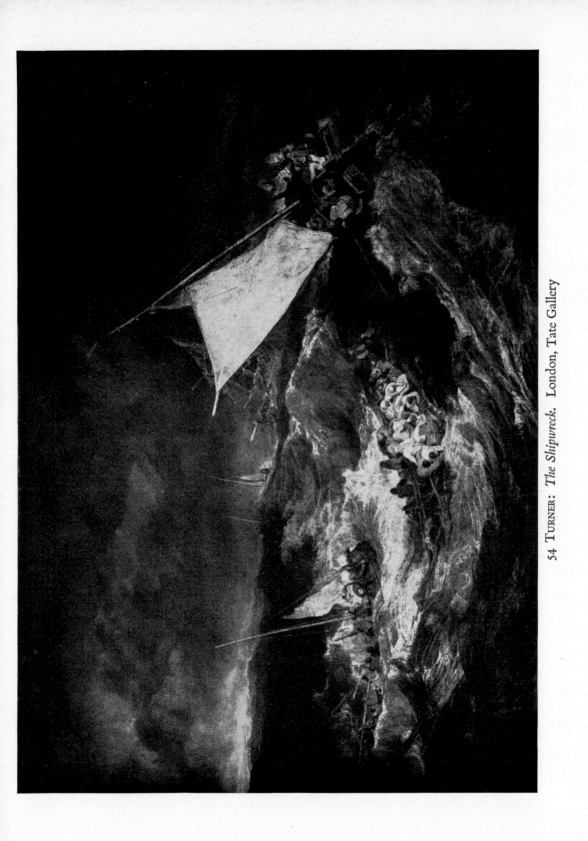

54 TURNER: *The Shipwreck*. London, Tate Gallery

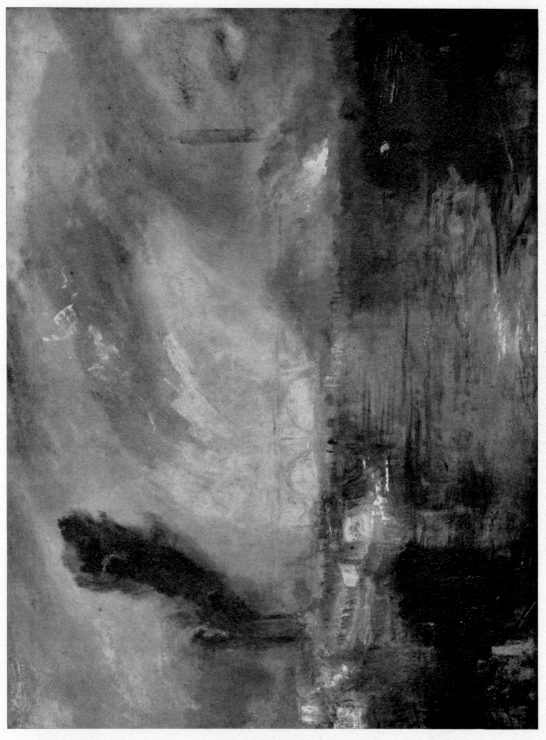

55 TURNER: *The Thames from Waterloo Bridge.* London, Tate Gallery

time he was attempting to convey the feelings aroused by his first visit to Italy, where the heat and glitter of the Mediterranean was symbolised by a key of colour so high that the darkest shadows are carmine or peacock blue. But these highly artificial concoctions could not satisfy him for long. He had written in the margin of Opie's lectures 'Every look at nature is a refinement on art', and it was necessary for him to relate his discoveries in the theory of colour to his acute perception of natural appearances and his marvellously retentive memory. This he achieved in the 1830's; and by the time of his last visit to Petworth, when he painted the famous *Interior*, he could render the visible world in progressions of colour as naturally and immediately as Mozart rendered his ideas in sound.

Having once more established a direct relationship with nature, he ceased to depend on 'poetic' subjects. Baiae was abandoned in favour of Waterloo Bridge, the Gardens of the Hesperides in favour of the Great Western Railway. In fact the new steam age suited him very well. The *Fighting Temeraire* tugged to her last berth is a sentimental picture, because, as a painter, Turner was not at all sorry to see the last of sail. He disliked painting sails—perhaps he was troubled by the memory of classical draperies—and the intricate geometry of rigging bored him. But he loved the brilliance of steam, the dark diagonal of smoke blowing out of a tall chimney and the suggestion of hidden furnaces made visible at the mouth of a funnel. All his life he had been obsessed by the conjunction of fire and water. It is the subject of his earliest oil, the Cholmondeley sea-piece, and of his many pictures of fire at sea, which often involved a certain straining of romantic imagery. The steamship gave him the opportunity of introducing it naturally. Sometimes this love of conflict between heat and cold leads to an opposition of red and blue which seems to us rather crude, although I think that the deafening discord in the *Fighting Temeraire* must be partly due to a change in the pigments. But in the *Snowstorm* everything is subordinate to the icy aquamarine of the whole, and the fires in the *Ariel's* stoke-hole reveal themselves only in two flashes of

lemon yellow. There is also a tiny red port-hole, reflected twice in the waves, and there are a few delicate touches of rose madder over the paddle-wheels. Otherwise the colour at the centre is cool, and was even cooler when the picture was painted, for the vertical glare of the rocket, now softened by a little dirt and yellow varnish, was once pure white. Only in the dispersing smoke and its reflection on the waves does some burnt umber give the necessary minimum of warmth.

How Turner drew from the recalcitrant medium of oil paint these refinements and transparencies is a mystery. No one ever saw him at work, except on varnishing day at the Royal Academy, and even then he took great pains to hide what he was doing. Of course he had a repertoire of technical tricks: but the delicacy of every touch is beyond mechanical skill, and leads us to look past the process to the state of mind in which such works were created.

By the time he came to paint the *Snowstorm* Turner's responses to nature had become extremely complex, and may be said to have operated on three or four different levels. The first response, and the only one to which he would admit, was the need to record an event. His exceptional powers of memory were deliberately strengthened by practice. Hawkesworth Fawkes, the son of his old patron, described how Turner studied a storm which they witnessed together over the Yorkshire hills, saying, when it was over, "There, Hawkey, in two years' time you will see this, and call it Hannibal Crossing the Alps." Besides this active and purposeful observation of the scene, there was a contemplative delight in the elements of colour and form which it presented. Turner, lashed to the mast and in danger of his life, has been able to look at the *Snowstorm* with aesthetic detachment. When it was over he remembered not only how the waves broke over the stern, but how the light from the engine-room had taken on a peculiar delicacy when modified by the blinding snow. At every point the visual data had adjusted themselves to his pre-established understanding of colour-harmony, so that this somewhat drastic look at nature was adding a refinement to art.

56 TURNER: Detail from *The Snowstorm*

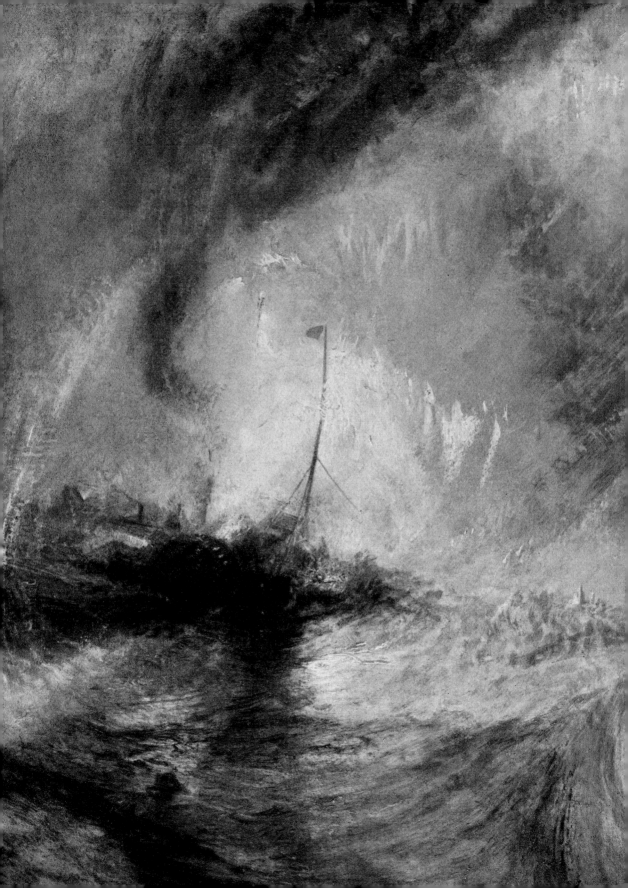

Turner

At another level is the actual choice of subject: the fact that he has chosen to paint this almost unpaintable episode instead of the golden beaches of Capua. Turner's deepest impulse was towards catastrophe, and Ruskin was right in recognising as one of his chief characteristics a profound pessimism. He believed that mankind was 'ephemeral as the summer fly', and his formless, intermittent poem, 'The Fallacies of Hope', which he kept going for over thirty years, is a genuine reflection of his feelings. Ruskin thought that this pessimism came over him 'owing to some evil chances of his life' about the year 1825. I cannot see any evidence for this date, for Turner's compositions, from 1800 onwards, are chiefly of gloomy subjects—the Plagues of Egypt, the destruction of Sodom, the Deluge; and Hannibal crossing the Alps, where a full-scale whirlwind is joined to the first quotation from 'The Fallacies of Hope', was painted in 1812. Ruskin knew more about Turner's life than he ever disclosed, and he may have known of some occurrence in the year 1825 to which he attributed what he called a 'grievous metamorphosis' in his hero's character. But to judge solely from his paintings, it was not till 1840, when he painted the *Slave Ship*, that death and destruction, blood-red and thundery-black, began to dominate his finest work. Thenceforward he looked for an apocalypse. His storms become more catastrophic, his sunrises more ethereal, and his ever-increasing mastery of truth is used in the projection of his dreams.

'Dreams', 'visions'—these words were commonly applied to Turner's pictures in his own day, and in the vague, metaphorical sense of the nineteenth century, they have lost their value for us. But with our new knowledge of dreams as the expression of deep intuitions and buried memories, we can look at Turner's work again and recognise that to an extent unique in art his pictures have the qualities of a dream. The crazy perspectives, the double focuses, the melting of one form into another and the general feeling of instability: these are kinds of imagery which most of us know only when we are asleep. Turner experienced them when he was awake. This dream-like condition

The Snowstorm

reveals itself by the repeated appearance of certain *motifs* which are known to be part of the furniture of the unconscious. Such, for example, is the vortex or whirlpool, which became more and more the underlying rhythm of his designs, and of which there is a strong suggestion in the *Snowstorm*. One is sucked in to the chaos and confusion, one's eye staggers uncertainly along the path of darkness which leads to the *Ariel's* hull and then shoots up into the blinding whiteness of the rocket. It is a dream experience; and I suppose that the apparent truth and the beauty of colour of the *Snowstorm* would not have affected me so strongly without this added appeal to my unconscious mind.

Snowstorm—steam-boat off a harbour's mouth making signals in shallow water, and going by the lead, by Joseph Mallord William Turner (1775–1851), is in oil on canvas, $35\frac{1}{2}'' \times 47\frac{1}{2}''$ (0.90 × 1.20 m.). It was exhibited at the Royal Academy in 1842, passed to the National Gallery with the Turner Bequest in 1856.

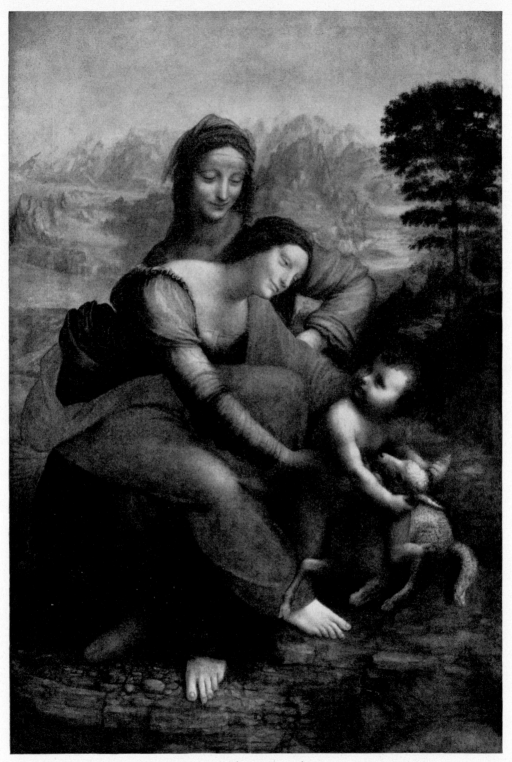

57 LEONARDO DA VINCI: *The Virgin with St Anne*. Paris, Louvre

LEONARDO DA VINCI

The Virgin with St Anne

To one who is not blinded by familiarity it must make a strange impression. It is like the speeded-up picture of vegetable growth or some very complex machine, designed to rotate and placed on a rotating platform. All the parts contribute to this movement and also have most intricate relationships with each other; and for a few seconds I am absorbed in following these complexities, oblivious of the subject matter, with a mental exhilaration similar to that of a musician following an elaborate fugue. But very soon my attention is fixed by the central pivot of the whole mechanism, the head of St Anne, smiling and withdrawn. How does her inscrutable inner life relate to the contrapuntal movement of the whole group? I feel certain that there is an absolute interdependence between the strangeness, the beauty and the scientific elaboration which strike me simultaneously when I first look at Leonardo's *Virgin with St Anne*. But how can it be defined?

Unwilling for the moment to face this problem, my gaze floats into the distance and wanders in the icy lunar landscape. But this Alpine expedition does not put an end to my questions, for I feel that this, too, is part of the same mystery; Leonardo is looking at the world as if from one of his projected flying machines, and seems to be pondering on its age and its ultimate hostility to human life. Clearly it is useless to examine Leonardo's picture with an innocent eye. Everything in his art turns one's thoughts to his life and to his restless intelligence.

He was an artist long before he was a scientist; in fact it was not until about 1483, when he was over thirty, that he began to ask

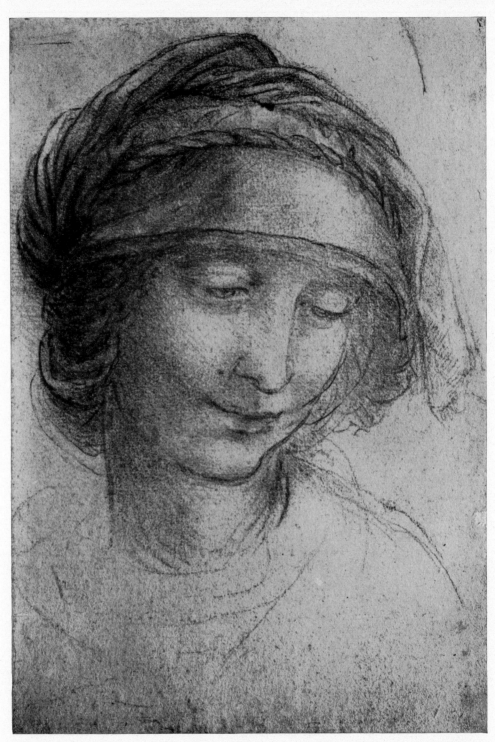

58 LEONARDO DA VINCI: Drawing for the head of St Anne. Windsor, Royal Library

questions and make notes of the answers. But in his earliest drawings his mind is already at work on one of the problems which were to occupy him throughout his life, what I may call the problem of pent-up energy. It appears first in a series of enchanting studies, rapid and apparently spontaneous, of a mother with a child on her knee, struggling with a cat. All three pull in different directions yet all are combined within a single form, so that the group could be modelled and turned round like a piece of sculpture. There, in relatively simple terms, is one germ of the *St Anne*.

What about the other, her inward-turning smile? That, too, one can find in Leonardo's early work, and most significantly in the first figure which seems to come from the depths of his imagination, the angel in the Louvre *Virgin of the Rocks*. That angel is quite different from the obedient, decorative angels of the fifteenth century. It knows a secret and this has made it smile, gently, almost humanly compared with the St Anne, but with the same air of complicity. And this kinship reminds me that Leonardo, like Blake, developed peculiar ideas about angels, seeing them not as guardians, but as intermediaries who, in order to warn man that his reason is finite, stand at his elbow and propound unanswerable riddles.

But I must not peer any further into Leonardo's mind without looking more carefully at our picture, and this time I begin to consider its subject. Being used to the iconography of Italian painting, I can see that it is meant to represent the Virgin Mary, her mother, St Anne, and the Infant Christ; but could anything be further from historical probability? One need think only of a Rembrandt drawing of the same theme, simple, domestic, humanly touching, to realise that Leonardo has made no attempt to picture the scene as it might have happened. Of course the same would be true of Raphael or of any classical painter of the high Renaissance; but they would have transformed ordinary experience because they believed that sacred persons should be endowed with unusual physical perfection. Leonardo's intention is meta-physical. His figures are peculiar because they have become symbols,

and in order to interpret these I must first of all try to discover what put them into his mind and then see how they were transformed by the pressure of his philosophy.

Before his time the best known representation of the *Virgin with St Anne* was the grave, gaunt picture by Masaccio in the Uffizi, in which St Anne stands directly behind her daughter like a ghost; and of about the same date are some more primitive versions of the subject, where a diminutive Virgin sits on St Anne's lap like a ventriloquist's doll. These pictures were certainly known to Leonardo, and I believe that something uncanny in the overshadowing presence of St Anne struck deep into his imagination. He saw her as an informing spirit, a *doppelgänger*, a control; in fact as something very close to his idea of an angel. The subject fascinated him, but the old stiff iconography was doubly unacceptable; it lacked that sense of movement which for thirty years had been the chief aim of Florentine art; and it failed to express his feeling of continuous involvement between mother and daughter. To achieve these qualities he engaged in the most sustained and resolute struggle with form of his whole career.

By rare good fortune the first phase of this struggle has come down to us. It is the large drawing, or cartoon, which hangs in the Council Room of the Royal Academy. Such drawings were intended to be full-size preparations for pictures, but Leonardo, who hated the manual labour of painting, evidently made them for their own sakes. The Burlington House cartoon could scarcely be more beautiful, and many lovers of Italian art have found it more to their liking than the picture in the Louvre. It was executed in about 1497, directly after the completion of *The Last Supper*, and gives us some idea what the massive figures of the Apostles must have been like before time and restoration had reduced them to stains upon the walls 'faint as the shadows of autumnal leaves'. Of all Leonardo's works it is the most classical in spirit, and I think there is no doubt that the Phidian grandeur of these flowing draperies was inspired by an antique relief. But for some reason it did not satisfy him. One may suppose that he felt the

59 MASACCIO: *Virgin and Child with St Anne.* Florence, Uffizi

left-hand side, below the arc of the Virgin's shoulder, to be rather weak and flat; and he may have been worried that the two heads, being on the same level, created two equal points of focus. Its very classicism may have been distasteful to him. It is too tranquil: it lacks the power of pent-up force. Beautiful as it is, I feel that the Burlington House cartoon did not come from the centre of his being. He left it for Luini to copy and set about other designs.

Two of these were done in Florence in the autumn of 1500 and the spring of 1501. Both are lost, but they were among his most admired works, and are known to us from careful contemporary descriptions. By relating these descriptions to drawings and copies we can form some idea what these cartoons were like, and can see how persistently Leonardo clung to his idea of movement so closely intertwined that the two figures seem to be one, with St Anne's head as the climax of the design. Ten years later, when he came to paint the Louvre picture, it had become almost a private problem, like the formulation of some mathematical theorem, which only a few initiates could understand. No wonder that the poses are improbable, so that when we meet the figures removed from their complex, as we do in certain pictures of Leonardo's school, they seem to be unbearably distorted.

But did he paint it? It has often been doubted, and this forces me to look at the picture again in a different spirit. People sometimes maintain that trying to find out who painted a picture from internal evidence is a futile and destructive occupation; but that has not been my experience. Problems of attribution have the advantage over iconographical problems that they compel one to look at the original picture. And as I search from place to place in the *Virgin with St Anne* for signs of Leonardo's hand my responses are sharpened far beyond the point of passive enjoyment, and the faculties of memory which are brought into play greatly increase my sensibility. I look, for example, at the Infant Christ's head, and discover the same exquisite egg-shell texture which I remember in the *Mona Lisa*. I look at the lamb's fleece, and notice that the curls have the same spiral as Leonardo's drawings of

160

60 LEONARDO DA VINCI: Detail of St Anne's head, from *The Virgin with St Anne*

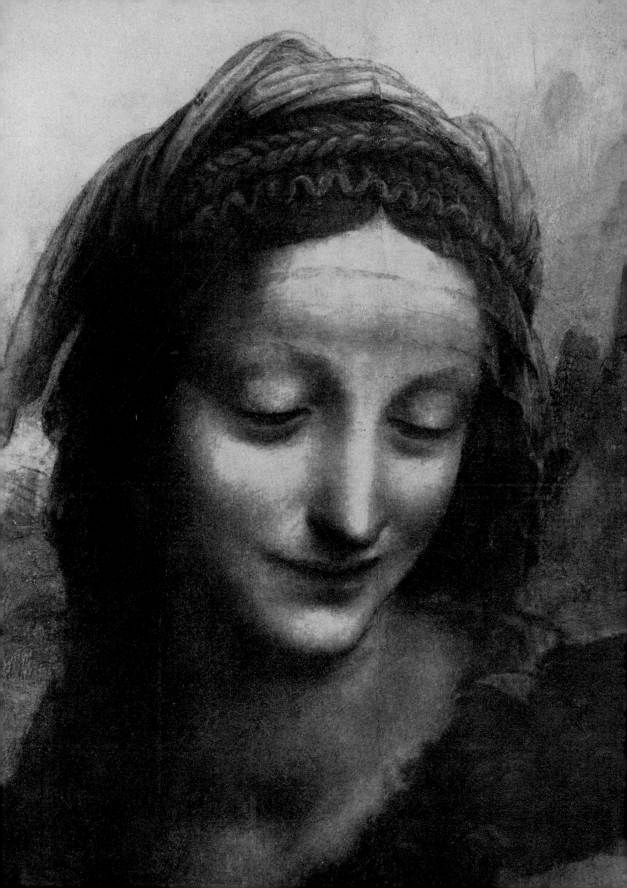

61 Leonardo da Vinci: Detail from *The Virgin with St Anne*

water-spouts. My eye passes down to the rocky platform, and I am at once reminded of his geological studies and am delighted to find between St Anne's feet some curious pebbles which only he would have bothered to paint so minutely. Most interesting of all, I suddenly remember where I have seen the form of that strange and rather repulsive piece of drapery which grows like a piece of fungus out of the Virgin's waist. It is in Leonardo's anatomical note-books of 1509, and in particular those which deal with embryology; and for a moment I pause fascinated by the complexity of his mind and the astonishing range of experiences he could compress into a single image. Finally, I return to the mountains, and there I have no doubts, for no one else but Leonardo had the knowledge of rock formation and the interest in aerial perspective to make these magical distances convincing: no one, at any rate, before Turner.

But what about the figures of the Virgin and St Anne ? They are in a technique quite unlike that of the other pictures by Leonardo which hang near them in the Louvre. They are painted lightly, almost as if in water-colour, and in places they seem to be unfinished, or rubbed away by a restorer. But Leonardo disliked the conventional use of oil paint, and loved to experiment with techniques. His drawings became looser and more evocative as he grew older; and there is a light, feathery study for the actual head of St Anne, very different in touch from the sharpness of his early drawings. I used to think it subtler and more mysteriously feminine than the painting; but I now see that in the creation of a powerful image like the St Anne some delicacy of individual character must be sacrificed, and I have come to believe that no one but Leonardo could have invented and executed the head which dominates this hermetic triangle.

By puzzling over this question of authenticity I have now come to know the picture in detail, and I can return to the total impression. It is still disturbing. I cannot enjoy it unquestioningly, as I might a Titian or a Velasquez. Once more I brood on the curious elements of which it is composed, the intertwined figures, the umbilical draperies,

the moonscape and the smile, and wonder how they are connected with one another. And an answer begins to form in my mind, which may not, heaven knows, be correct, but is at least in keeping with Leonardo's spirit.

I remember that the *Virgin with St Anne* was painted at a period in his life when his mind was absorbed by three scientific studies, anatomy, geology and the movement of water. The movement of water symbolised for him the relentless continuum of natural force; anatomy the complexity of life and its power of renewal; and from his geological studies he had formed the concept that the whole world was breathing and renewing itself like a living organism. In one of his manuscripts he says: 'The earth has a spirit of growth. Its flesh is the soil, its bones the stratifications of the rock which forms the mountains, its blood the springs of water; and the increase and decrease of blood in the pulses is represented in the earth by the ebb and flow of the sea.

Everything in nature, even the solid-seeming earth, was in a state of flux. But the source and centre of this continuous energy remained mysterious to him. He could only symbolise it by this ideal construction, in which forms, themselves suggestive of further lives, flow in and out of one another with inexhaustible energy; and at the apex of this vital pyramid is the head of Leonardo's angel-familiar, smiling, half with love for human creatures and half with the knowledge of a vital secret which they can never possess.

The Virgin with St Anne

The Virgin with St Anne, by Leonardo da Vinci (1452–1519), is in oil on panel, measuring 67″ × 50¾″ (1.70 × 1.29 m.). It seems to have been painted about 1508 and is the final version of a subject which had been occupying Leonardo for about ten years. It is still unfinished, e.g. in the Virgin's drapery, and there are a number of drawings, and copies of drawings, by Leonardo, chiefly at Windsor, which show what further elaborations he had in mind. The picture was evidently well known in Italy, as there are at least a dozen copies of it by north Italian artists, some of them more or less contemporary.

The Louvre picture is usually assumed to be the one described by Antonio de Beatis, secretary to the Cardinal Louis of Aragon, who with his master visited Leonardo at Cloux, near Amboise, on October 10, 1517. But de Beatis says that Our Lady and her son 'are placed in the lap of Saint Anne' (*che stane posti in grembo de Sancta Anna*). The infant Christ, in the Louvre picture, is on the ground; in some of Leonardo's other versions of the subject He is, together with His mother, in the lap of St Anne. So the identification is by no means certain. If the Louvre picture was in Cloux, it must have been taken back to Italy after Leonardo's death, perhaps by his friend Francesco Melzi, as it was in Casale when Cardinal Richelieu bought it in 1629. He brought it to Paris, and gave it, together with his hotel, to Louis XIII in 1639. It passed with the French royal collection to the Louvre in 1801.

62 COURBET: *L'Atelier du Peintre.* Paris, Louvre

COURBET

L'Atelier du Peintre

I T IS more like a dream than any other great painting known to me.
We do not dream a Bosch or a Delacroix: they are too consistent
in their fantasy or romanticism. But in the *Atelier* moments of
intense reality and sudden heightenings of sensuality are succeeded by
baffling inconsequence; there is a reunion of characters who seem both
familiar and strange, and maintain a speechless isolation from one
another, as if under the spell of an enchanter; and there is the setting of
a transformation scene in which the back-cloth will gradually dissolve
and reveal some unattainable distance. This dream-like interweaving
of the real and the symbolic Courbet expressed quite accurately when
he entitled his huge machine 'Allégorie réelle: intérieur de mon
atelier, déterminant une phase de sept années de ma vie artistique'.
But what a terrible picture that title suggests! That it is not a salon
monster (and was in fact rejected from the Salon of 1885) is due to its
extraordinary pictorial qualities.

Courbet was a born painter. Everyone who watched him at work
was astonished at the way in which his beautiful hands could make
the brush or the palette-knife convey the subtlest tone or the richest
substance. I like to approach the *Atelier* from the west staircase of the
Louvre so that I can see it through the doorway, glowing in the
afternoon sun. My eye then dives into the warm sea of tone and colour,
and for some minutes is content to swim about, delighting in each
wave and ripple of beautifully rendered optical sensation. As nine-
teenth-century amateurs used to say, "C'est de la peinture!"

But very soon I begin to ask questions. What do all these figures

mean? Are they simply the memories of seven years, which have come unbidden; or have they been invited for some purpose? "C'est passablement mystérieux," said Courbet. "Devinera qui pourra." He who can will guess.

Some of the answers are simple. In the centre Courbet, the prophet of realism, is supported by two examples of truth in art, a landscape of his own Franche-Comté and a superb, unidealised nude model. A peasant boy watches the master at work with innocent admiration, and we are led to infer that his judgement is preferable to that of the academicians. To the right, we may guess, are the men who have influenced Courbet; and if we are familiar with the period we have no difficulty in recognising M. Bruyas, his long-suffering and slightly dotty patron, and his friend Proudhon, the socialist philosopher, whom Mr Clive Bell once described as the biggest donkey in Europe. The gloomy seated man is Champfleury, who was the first advocate of Courbet's realism. As for the figure on the extreme right, we happen to know that it represents Baudelaire, because it corresponds to a portrait that Courbet painted of the poet seven years earlier; but it bears little resemblance to other portraits of Baudelaire, and in fact Courbet complained that his face changed every day.

With the lady in the shawl, however, the scheme breaks down. Courbet subsequently called this couple 'amateurs mondains', but she is painted with great warmth, and she is obviously there simply because he liked the look of her. To the left there is a similar collapse of logic. No doubt there was a sociological excuse for *l'Irlandaise*, the figure of ultimate poverty who sits on the ground beside his canvas, for it had not escaped the attention of continental Europe that the richest country in the world had within its borders several million starving and ragged savages; and in the shadowy depths behind her are several other figures suggested by philosophy—a priest, a prostitute, a grave-digger and a merchant, who symbolise the exploitation of our poor humanity. But nothing in Proudhon explains the Rabbi on the extreme left, still less the hunter with his dogs, who, like the 'amateurs mondains', seems

63 COURBET: 'Amateurs mondains', from *L'Atelier*

to be agreeably free from social consciousness.

Of course, it is this absence of system which saves the *Atelier*. The figures which had been haunting Courbet's imagination for seven years had come there for a number of reasons. They had pleased his eye, influenced his life, stealthily entered his subconscious. In 1855 a comparable picture was being painted in England, Ford Madox Brown's *Work*; and Brown introduced many of the same ingredients: the workers, the beggars, the ragged children, the philosopher friends, even the 'amateurs mondains'. But, as we know from a much too long description by Brown himself, the whole was conceived in terms of literature, and can properly be classed as an illustration, on a heroic scale, to Carlyle's *Past and Present*. Whereas in the *Atelier* every figure is a personal symbol related to a visual experience, and it is not Proudhon's philosophy but the mysterious workings of the pictorial intelligence which have brought them together.

After wandering in this mixed company, we return to the painter at his easel. Courbet has given himself a splendid appearance and for once in the history of self-portraiture we know that it was justified. This was an age of cruel observers. Dozens of them described Courbet in detail and all agreed about his beauty. He was tall and olive-skinned with long black hair and huge bovine eyes. His friends were struck by a likeness to the young Giorgione, and this was not lost on the painter himself, who entitled one of his finest self-portraits 'a study in the Venetian manner'. They also told him that his eyes were like those of an Assyrian king. Courbet obligingly grew a long, pointed beard, and it is this Assyrian phase that he has commemorated in the *Atelier*.

He was as shamelessly delighted with himself as a prize stallion. A year after painting the *Atelier* he was invited to luncheon by the Comte de Nieuwerkerke, Napoleon III's Director of Fine Art. A long letter to Bruyas describes the episode, which is a model of how an artist should behave to an official. M. de Nieuwerkerke took both his hands and said he wanted to act frankly with him. He must moderate his style, put some water in his wine, etc., and the Government would support him.

L'Atelier du Peintre

"I answered", said Courbet, "that I too was a Government . . . and that I was the sole judge of my own painting. I added that I was not only a painter but a man, that I did not make art for art's sake but to vindicate my intellectual liberty, and that I alone of all my contemporaries had the power to translate and render in an original manner, my personality and my society."

To which he replied: "Monsieur Courbet, vous êtes bien fier."

"Monsieur, je suis l'homme le plus orgueilleux de France."

We must remember that he had come from a country district and had never experienced the bewildering complications of metropolitan life. He saw no reason to conceal his strength, to moderate his laughter or to think twice before voicing an opinion or breaking into song. He was really Blake's ideal man, although neither would have cared much for the other's art.

At first Courbet had considerable success. He won a medal in the Salon of 1849 and in the next few years many of his pictures were accepted, although they aroused an ever-increasing storm of academic fury. Then in 1855 all the pictures sent to the International Exhibition were refused. Courbet immediately hired a garden full of lilac in the Avenue Montaigne, built a gallery and exhibited forty-three of his pictures, including several of colossal size. Among them was *L'Atelier du Peintre*, painted during the preceding months in the intervals of a severe attack of jaundice. The public reacted as they did to all great works of art in the nineteenth century: they roared with laughter. Not until the Impressionist exhibition, twenty years later, did the public again have such a good laugh. But Delacroix, who was alone in the exhibition for an hour, was deeply impressed. "They have rejected", he said of the *Atelier*, "one of the most extraordinary works of the age."

Courbet was thirty-six when he exhibited his masterpiece, and in some respects it was the climax of his career. He continued to dream of, and talk about, huge canvases which should celebrate democracy and decorate railway stations. He wasted a lot of time on a large

picture of tipsy priests returning from a conference, with which he hoped to shock the Empress Eugénie. But his best works were small celebrations of things which please the senses—fruit, flowers, waves, shining trout and girls with red-gold hair. In 1867 he again put on a one-man show: "J'ai fait construire une cathédrale . . . Je stupéfie le monde entier." The exhibition aroused little comment, for by this time Courbet's theories were accepted, and, compared with the work of Renoir and Monet, his pictures had the tone and texture of Old Masters.

Alas, this splendid apostle of the senses ended badly. He became extremely fat and more noisily self-assertive than ever. The authorities must have longed for a chance to get rid of him and in the end they had one. The Column in the Place Vendôme was pulled down during the disturbances of 1871, and Courbet was held responsible, unjustly as it happens, although such an escapade would have been quite in character. He was put in prison and offered the alternative of paying for its reconstruction or imprisonment for five years. He escaped to Switzerland and after a short period of miserable tranquillity, during which he is said to have drunk twelve litres of wine a day, he died.

The catalogue of the 1855 exhibition contains a preface in which Courbet sets down his aims more shortly and more sensibly than is usual on such occasions. The title of Realist, he says, has been forced upon him just as the title of Romantic was forced on the men of 1830. And he concluded: 'Savoir pour pouvoir, telle fut ma pensée . . . faire de l'art vivant, tel est mon but'. It is a fair statement. He painted what he knew—his own countryside, his neighbours, his friends— and his art is alive. But in one respect he was also a romantic. "To love oneself", said Oscar Wilde, "is the beginning of a life-long romance", and it is evident that every time Courbet represents himself the character of his art changes. There is nothing realistic about those marvellous self-portraits, *The Wounded Man* and *The Man with a Pipe*; in them he is as whole-heartedly romantic as a follower of Giorgione. The *Atelier* is, among other things, a great poem of

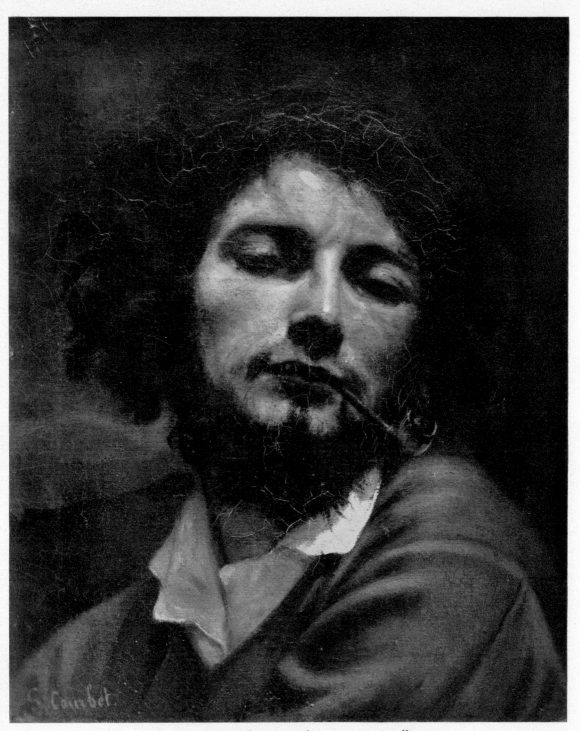

64 COURBET: *The Man with a Pipe*. Montpellier

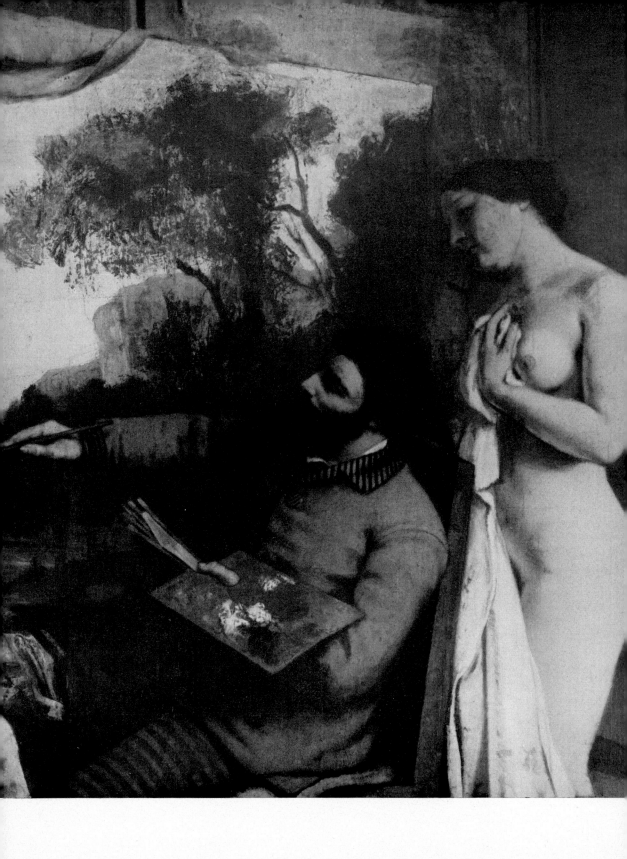

self-love. Just as Mallarmé and Valéry were to make poetic inspiration itself the subject of poetry, so Courbet has taken as the subject of his masterpiece his own pictorial inspiration. That it is so great a painting is due to the extraordinary richness of his experience.

And as I look more attentively at the *Atelier*, I realise how misleading is the notion that Courbet's art was made up of hand, eye and appetite. French critics love to repeat that he painted as an apple-tree grows apples. What nonsense! The most hasty analysis shows that the *Atelier* is the production of a powerful intelligence.

Take the central group alone. Courbet has portrayed himself almost in profile, with his arm stretched out horizontally, and has related this hieratic stiffness to a series of interlocking rectangles, so that he seems to be a stable element in the midst of the floating population which surrounds him. More than that, he is a plastic element, a relief from Persepolis, and this feeling of timeless plasticity is enhanced by the nude model, also in profile, whose grandiose outline is a perfect foil to the thin geometric shapes of chair and canvas. This is not the fruit of a vegetable procedure, but of a rigorous devotion to the tradition of art.

Even his opponents admitted that Courbet had studied the old masters with profit. He said that his first revelation of art had been the sight of *The Night Watch*, which is, indeed, one of the few great pictures painted with an appetite as hearty and unfastidious as his own. He continued to copy Rembrandt throughout his life. But his chief source of instruction was the Spanish school, known through the gallery of Louis-Philippe. In the *Atelier* the lady with the shawl seems to derive from the school of Seville, the mysterious figure strung up immediately behind his canvas is one of Ribera's tortured saints. And the huge room is full of echoes of Velasquez, in the hunter with his dogs, in the beggars, and in the whole sense of space which derives from both the *Meniñas* and the *Hilanderas*. But, as Courbet had never been to Spain and knew these masterpieces only in engraving, his tonality is much warmer and closer to Ribera, whose *Club-footed Boy*

65 COURBET: The artist and his model, from *L'Atelier*

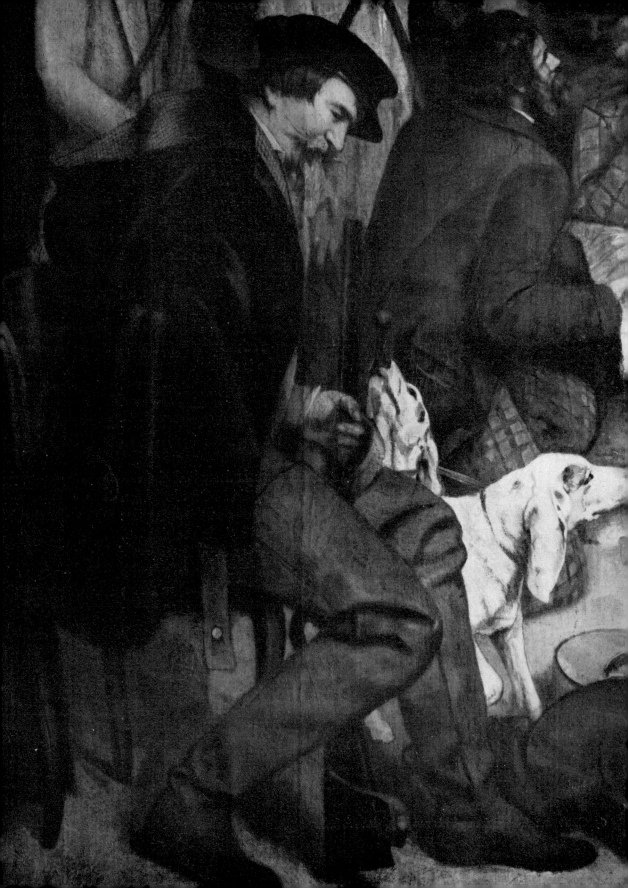

in the Louvre had a decisive influence on French nineteenth-century painting. The cool detachment of Velasquez would have dismayed him.

Nor is Courbet's intelligence limited to the science of picture making. The *Atelier* was painted in the interval between Balzac and Flaubert, and seems to bridge their two worlds, Balzac on the left, Flaubert on the right. It justifies Courbet's boast that he alone of his contemporaries had been able to relate the art of painting to the society of his day. Hanging where it does in the Louvre, it seems like the last act in that great drama of French history which begins with David's *Oath of the Horatii*; the earliest manifesto of the revolution, passes through the Napoleonic adventures of Baron Gros, and culminates in Géricault's *Raft of the Medusa*. The age of heroic action is over, but, as Courbet's powerful hand evokes these characters from the shadows, we recognise how France still dominated the life of the mind.

L'Atelier du Peintre, by Gustave Courbet (1819–1877), is in oil on canvas, measuring 142″ × 235½″ (3.61 × 5.98 m.). It was painted and signed in 1855, and was sold from the artist's studio twenty-six years later, in December 1881. It entered the collection of Haro and Desfosses, and was bought for the Louvre in 1920.

66 COURBET: The hunter and his dogs, from *L'Atelier*

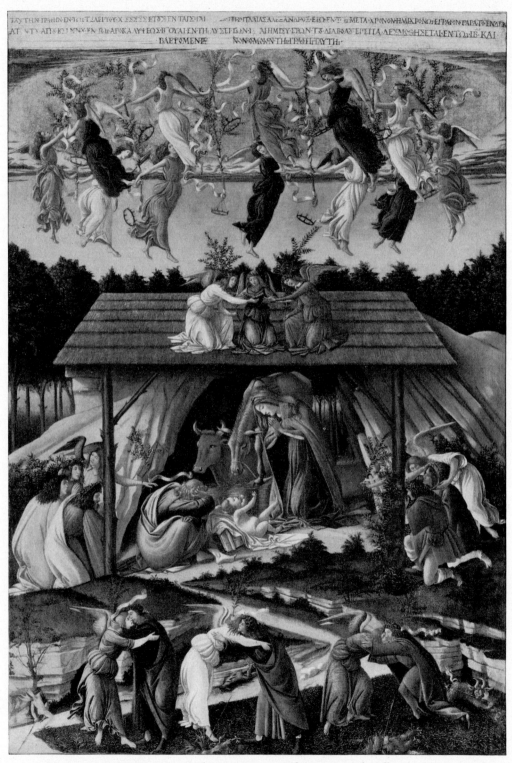

67 BOTTICELLI: *The Nativity*. London, National Gallery

BOTTICELLI

The Nativity

A PAINTING of Christ's Nativity is often a comfortable Christmas card. Botticelli's picture is the reverse. It is the record of a spiritual struggle, a pilgrim's progress in which the pain is remembered.

On earth there is a strenuous convergence of diagonals. The paths and rocky walls zigzag angrily, their movements only slightly modified by the three figures in the foreground ('men of goodwill', as their fluttering scrolls inform us) who are receiving angelic comfort, and whose angular poses ascend in contrary direction to the plot of ground on which they stand. At the sides of the cave the scars in the rock are like the lances of an invading army, and within it there is a design of dangerous sharpness, as of some complex machine which will cause us pain unless we can master it. The sharpest point touches the Virgin's brow.

But above the roof the rhythm changes. The angularities of trouble are cut short, their halt made less abrupt by a fringe of trees, and there appears in the clear winter sky, capped by a golden dome, a circlet of angels so light, so free in their ecstatic movement from the discords of human conflict, that they remain in the mind's eye as the purest expression of heavenly bliss.

> I see
> The heavens laugh with you in your jubilee:
> My heart is at your festival,
> My head has its coronal
> The fullness of your bliss, I
> Feel—I feel it all.

179

Botticelli

The *Nativity* is not one of those pictures which can be enjoyed through the eye alone. It is, in the best sense, a literary picture, to be read and slowly unriddled in the light of all that we can know about the painter and his times; and it even contains a long inscription which is an integral part of the whole. This is in Greek capitals, and, although it is unlikely that Botticelli knew Greek, it is obviously painted by his own hand. This is the only time he ever signed a painting, and clearly it had a special importance to him.

'I, Sandro, painted this picture', he says, 'at the end of the year 1500 in the troubles of Italy'; and he goes on to state that, after a time foretold by St John, the Devil will be chained and 'we shall see him trodden down, as in this picture'. Actually, we do not see this. There are four minor devils who have been transfixed with lances; also both Botticelli's references to the Book of Revelation are incorrect. But the general meaning of the inscription is clear, and we are led to ask why the painter of the *Primavera* and *The Birth of Venus* comes to be in this apocalyptic state of mind?

Even in his early work what distinguishes Botticelli from the other artists of his generation is his spiritual tautness. While his colleagues were concerned with rendering the movement of the body, he was always occupied with the stresses of the soul. But this religious temper was complicated by an almost morbid hunger for physical beauty. And when the humanist philosophers of the Medicean circle persuaded him that the inhabitants of Olympus, even that witch Madam Venus, could be made to symbolise Christian virtues, we can imagine how willingly Botticelli accepted their fine-spun arguments. But how little of a pagan he became! Nothing could be further from the thoughtless, full-bodied, fruit-like gods of antiquity than his anxious divinities. And in the early 1490's he received from the same patron who had ordered *The Birth of Venus*, Lorenzo di Pierfrancesco de' Medici, a commission of a very different kind, an immense series of illustrations to Dante.

The Florentines of the fifteenth century studied Dante in much the

68 BOTTICELLI: Angel embracing a 'man of goodwill', from *The Nativity*

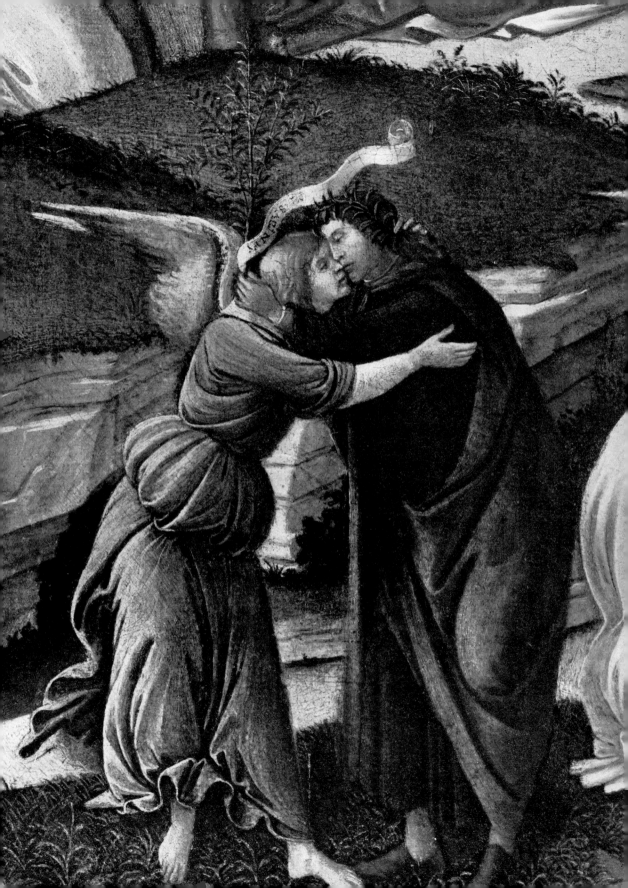

The Nativity

same spirit as the Greeks of the fifth century (whom they so closely resembled) studied Homer; for information, for precept and for religious guidance. Botticelli's years of application to this task must have had a profound influence on his mind, and it is in the Dante drawings, of which over a hundred have survived, that one finds for the first time the uncorporeal lightness of his later work. They are the most Oriental works of Western art. They achieve their purpose by pure outline, which floats and dances with the same disregard of substance as thirteenth-century illustrations to *The Tale of Genji*. The hard-won laws of perspective, of which Botticelli had been the acknowledged master, are abandoned, and the figures are sprinkled over the pages like holy hieroglyphics.

Some of this oriental character survives in the *Nativity*. But compared with the decorations at Ajanta or Horajui, how complex is its design, how dreadfully urgent its message! This vision of joy and love has not been achieved, as in a Buddhist painting, by peaceful contemplation, but through participation in disasters.

Botticelli's experiences in the 1490's were such as would have bruised a stronger spirit than his. His patron and close friend, Lorenzo di Pierfrancesco, was the enemy of Savonarola. Yet Botticelli's brother Simone, with whom he shared a house, was an actual follower of the *frate*, and one cannot doubt that Botticelli himself was moved by the power of that high, haunting voice which had driven the Florentines into a state of hysteria. In 1497 his patron was forced into exile; in 1498 Savonarola's body was burnt in the Piazza della Signoria, and the conquering armies of France threatened the tranquillity of every State in Italy. By 1500 the troubles of Italy were real enough, and the most realistic mind in Europe was seeking for a saviour, though emphatically not for a Prince of Peace. There were also less real troubles. The two references to the Apocalypse in Botticelli's inscription remind us that just before the half-millennium there was an outbreak of that fear of universal destruction which had afflicted men's minds five hundred years earlier, and from which we are not altogether

69 BOTTICELLI: Detail of illustration to Dante's *Purgatorio*, XXXIII. East Berlin, State Museum

free as the year 2000 approaches. The night which preceded the blissful morning of Botticelli's *Nativity* must have been exceedingly dark.

The *Nativity* is in many respects an archaic work. Botticelli has accepted Savonarola's denunciation of realism, and drawn his Virgin and Child on a different scale from the subordinate figures, as a Byzantine painter would have done. He has made no attempt to create an illusion of depth, and has set the thatched penthouse in the centre of his scene, frontally to the spectator. The foreground figures have this same archaic flatness, as if to represent them in the round would be to introduce too strong a flavour of mortality. But such scruples need not be extended to Heaven, and the angels are far from archaistic. Ruskin called them pure Greek, and in fact their billowing draperies and thrown-back heads do derive from the maenads of the fourth century. He also called them 'faceless', by which he meant he averted his eyes from their faces, because they are no longer pretty. Savonarolan puritanism has made Botticelli renounce the physical beauty which he still thought appropriate to the blessed spirits in his Dante drawings. He has not been able to shake off the habit of sensitive observation on which his wonderful powers of draughtsmanship were based, and the thin arms are still drawn with delight. But the draped bodies are as angelically immaterial as anything in Byzantine art. This is the least sensuous dance in painting. If we join it, we do so with our spirits only, and as we move round the circle, swayed by the cross-currents of draperies and wings, pausing at magical patterns of crowns and palm-leaves, we may fancy that the heavenly music of the initiates may yet be audible to our corrupted senses. But for all its archaism and its renunciation of material things, the *Nativity* is not at all a 'precious' work. It is, on the contrary, a strong picture, strong in design, grave in colour, vigorous in execution. Before a recent cleaning its strength was partially concealed by a tapestry-like unity of tone, but now the interplay of colour enhances the energy of the design.

In the foreground wine-red draperies complement the mossy greens; to the right the shepherds are a subtle contrast of grey and

70 BOTTICELLI: Part of the Celestial Dance, from *The Nativity*

brown, given life by the whitest angel in the whole picture. To the left the kings, although puritanically deprived of their regalia, are allowed more festive colours, and there is a soft, rainbowish kind of pink in the angels' wings. But the central harmony, the grey of the rocks and the ass and the cold blue of the Virgin's mantle, is extremely severe, and reminds us that near the top of the *Monte Sancto di Dio* the air is too pure for human breath.

Cleaning has also heightened the contrast between earth and heaven. Only now, can we realise how clear and cold is the winter sky, and I confess that I had never before observed the small clouds, as jewel-like as the clouds of Altdorfer, which infringe the golden dome. The painting of the foreground is much richer than I had supposed. The three groups have gained in importance and I am led to speculate on their meaning. Can these olive-crowned martyrs be a cryptic representation of Savonarola and his two companions? Or do they, as seems more probable, symbolise all those who have come through great tribulation? In either case these figures stretching out their arms to one another, their heads touching, their bodies far apart, are the visual equivalent to those reunions of the Blessed Spirits which reward us in the *Paradiso*.

The *Nativity* was the first of Botticelli's pictures to reach England, and when it was exhibited at the Royal Academy in 1871 it seemed to confirm the spirit of pre-Raphaelitism in its second, poetic phase. The effect of the angels on Burne-Jones is obvious enough, although he was so far from the strain and struggle which underlay Botticelli's vision. For Ruskin, on the other hand, this latent hysteria was an added reason for enthusiasm, and set him off on one of his own most memorable visions: 'Suppose that over Ludgate Hill the sky had suddenly become blue instead of black, and that a flight of twelve angels covered with silver wings and their feathers with gold had alighted on the cornice of the railroad bridge as the doves alight on the cornices of St Mark's at Venice, and had invited the eager men of business below, in the centre of a city confessedly the most prosperous

VI Botticelli: Angel showing the Shepherds the Infant Christ, from *The Nativity*

in the world, to join them for five minutes in singing the first five verses of such a psalm as the 103rd—"Bless the Lord, oh my soul, *and all that is within me* (the opportunity now being given for the expression of their most hidden feelings), all that is within me bless His holy name, and forget not all His benefits"—do you not even thus, in mere suggestion, feel shocked at the thought, and as if my now reading the words were profane.'

Ever since I read this paragraph in *The Eagle's Nest*, over thirty years ago, it has been in my mind when I look at Botticelli's *Nativity*. It is not the kind of response to painting which has been considered acceptable during those years. But is it so far from Botticelli's intention? And, as this question forms in my mind, I begin to reflect on the shaky foundations of art history. Before the time of Leonardo da Vinci we have very little evidence of how painters regarded their art. Some scholars believe that they were simply craftsmen who derived all their ideas from learned patrons. Others assume that they were able to master the most complex systems of philosophy and embody them in their works. I do not know which is nearer the truth. But I am fairly certain that Botticelli was a man of the finest intelligence which he applied to the subjects of his pictures as well as to their design: that, for example, his *St Augustine* in the Ognissanti is the result of profound meditation on the Confessions, and that in the *Nativity* every movement has a meaning which becomes apparent only when we have steeped ourselves in the thought and imagery of his time.

The Nativity, by Alessandro Filipepi, called Botticelli (c. 1445–1510), is in oil on canvas, 42¾″ × 29½″ (1.085 × 0.75 m.). As the inscription implies, it was painted at the end of 1500. Although a direct connection between this picture and the death of Savonarola cannot be proved, it comes very close in spirit to some of Savonarola's sermons, notably his sermon on the Nativity of 1493. It combines two iconographical traditions: the Byzantine, according to which the Nativity took place in a cave, and the early fifteenth-century tradition, influenced by the Vision of St Bridget, in which the Child appeared miraculously before the kneeling figure of the Virgin.

It was bought from the Villa Aldobrandini, Rome, by William Young Ottley about the year 1800. After various changes of ownership it was bought in 1851 by W. Fuller Maitland, by whom it was exhibited at Manchester in 1857. It was purchased from him for the National Gallery in 1878.

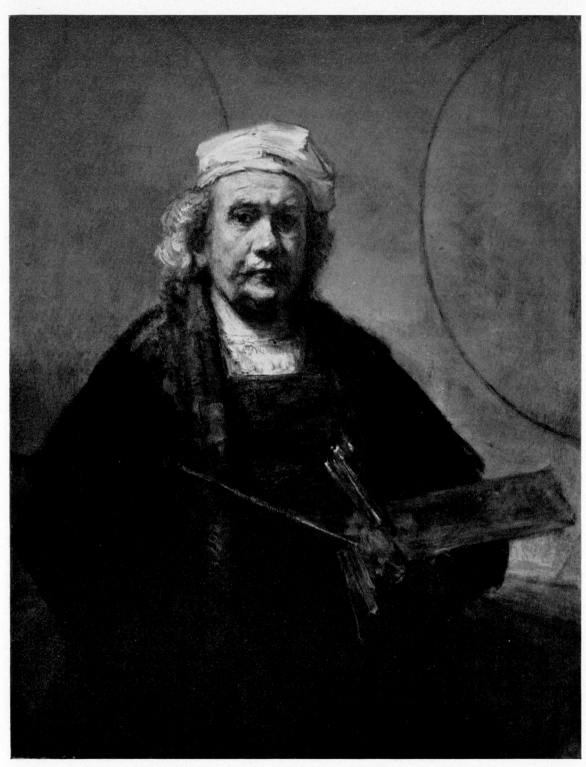

71 REMBRANDT: *Self-portrait*, c. 1663. London, Kenwood

REMBRANDT

Self-Portrait

How well we know that face—far better than we know our own, or the faces of our friends. We cannot select the essential and memorable ingredients of a face with so much candour and compassion. We do not know how the exact shape and tone of every furrow is related to experience. We cannot accept ourselves without a few excuses and hopeful embellishments. Rembrandt's self-portraits are the greatest autobiography ever presented to posterity, and as I look at this noble picture at Kenwood my first thought is of the soul imprisoned in that life-battered face. Perhaps that is always true of a great portrait. It is primarily the record of an individual soul. The painter must concentrate all his forces on this act of interpretation, and the mastery of design, which may first catch our attention when several figures are represented, is forgotten when a single head compels our interest.

The simple-looking construction of a portrait is often illusory. Every painter knows that there are few more exacting problems in the science of picture-making than to invent a pose which shall be both natural and commanding, stable and dynamic. The simplest poses, like the simplest tunes, are almost miraculous discoveries. The folded hands of the *Mona Lisa* or the gloved hand of Titian's *Homme au gant* continued to provide painters with convenient motives for centuries after they were painted. Professional portrait painters have been driven to elaborate subterfuges, so that Reynolds arranged his ladies in the attitudes of Michelangelo's sibyls and Ingres would choose a sitter only if she could fall into the pose of Greco-Roman sculpture.

Rembrandt

Rembrandt himself took notes of all the portraits which could possibly help him, even those which seem furthest from his style. He did exquisite copies of Moghul miniatures and scribbled sketches of Roman busts. Raphael's *Castiglione*, which he noted at an auction sale, he made the basis of his self-portrait in the London National Gallery.

This long discipline in pictorial science makes the Kenwood portrait a masterpiece of design, and for a minute I am prepared to look away from Rembrandt's face and admire the skill with which it has been placed in the canvas. It is massive, dominating, apparently inevitable, and the effect has been achieved by a kind of geometrical simplicity in every form. By the time this picture was painted—and it must date from about 1660—he had long abandoned the fruity baroque shapes of his prosperous years, the shapes which encumber *The Night Watch* like a Victorian sideboard, and had begun to build up his designs, as the great painters of the Renaissance had done, on cubes and triangles. It was a development analogous to that of Cézanne, and as that name comes to mind I look up at the white cap which Rembrandt is wearing, and my delight in it is increased by observing how extraordinarily similar it is to one of Cézanne's napkins, both in touch and in structure. It has the same clear understanding of how one plane is related to another, expressed with the same loving, candid strokes of the brush. Cézanne painted for himself alone, and, by this time, so did Rembrandt. He was isolated, bankrupt and free; and so he could indicate the brushes and palette in his left hand with an expressive geometry very close to the painting of our own day and far from the careful polish of mid-seventeenth-century Holland. The same is true of the two grandiose arcs which he has drawn on the wall to take the place of the looped curtains and cornices of conventional portraiture. They are like the secret signs made by tramps on gate-posts, conveying their message more vividly than any realism, yet not without some hint of mystery as well.

But although there is so much to admire in the design, I soon return to the head. Even if that head had emerged unsupported

72 REMBRANDT: Drawing of himself when young.
London, British Museum

from the darkness, as with Rembrandt it often does, this would be a great picture. All artists have an obsessive central experience round which their work takes shape. Rembrandt's was the face. It was to him like the sun to Van Gogh, the waves to Turner or the sky to Constable, the 'standard of scale, the organ of sentiment', the

microcosm of a comprehensible universe. As a youth of twenty-two, when his subject pictures are still loutish and derivative, his paintings and etchings of his parents are subtle and masterly; and from the first he paints himself.

A quantity of pictures, drawings and etchings done in the 1620's show us the tough young student of Leyden University at no pains to disguise his plebeian nose and truculent mouth. Why did he begin this astonishing series, to which there is no parallel in the seventeenth century, or, indeed, in the whole of art? At this date we cannot say a desire for self-knowledge, for the young man in the early self-portraits is clearly not the introspective type. Nor can it have been due solely to shortage of models, although it is true that for the eager self-educator no other model is quite as convenient. No doubt there was an overflow of vital egotism, but this is true of many young artists; and perhaps the effective reason for the early self-portraits should be deduced from the first critical reference to Rembrandt by the Dutch connoisseur Constantyn Huygens, who says that his peculiar excellence lay in vivacity of expression (*affectuum vivacitate*). The young Rembrandt—he was twenty-five at the time—set himself to give visible form to human feelings; and at first this meant simply making faces. He portrayed himself because he could make the faces he wanted, and could study the familiar structure of his own head distorted by laughter, anger or amazement.

But what was he making faces at? A man must laugh or scowl at something. The answer is that Rembrandt was making faces at polite society. His early biographers all lament that (in their words) 'he frequented the lower orders' and 'would not make friends with the right people'. The most revealing of all his early self-portraits is an etching of 1630, in which he portrays himself as his favourite subject, a tousled and unshaven beggar, snarling at the prosperous world which was soon to engulf him. In a sense 'engulf' is the wrong word. From 1632 to 1642 Rembrandt rolled and spouted in success like a dolphin. Bored by the black cloth and stiff white linen of his rich and prudent

73 REMBRANDT: Himself as a tramp. Etching

sitters, he lived in fancy dress. He covered his smiling, gap-toothed Saskia with satin and brocade, he disguised himself in fur and armour. But it was no good. He could not disguise his nose. There it was, the broad, bulbous truth, waiting to reassert itself as soon as this time of exuberant make-believe was over. It came to an end gradually, about the year 1650, and that is the date on a picture in Washington (Widener collection) where for the first time one feels that the motive

193

for his self-portraits has changed. He still wears the gold braid of fancy dress, but in the sad countenance all attempt at disguise has been dropped. The jolly toper has gone for ever and so has the grimacing rebel. He no longer needs to make a face: time and the spectacle of human life have made one for him.

Unconsciously he has come to see that if he is to penetrate more deeply into human character he must begin—as Tolstoy, Dostoevsky, Proust and Stendhal began—by examining himself. It is a process that involves the most subtle interplay of detachment and engagement. To counteract the self-preserving vanity which makes so many self-portraits ridiculous, the painter must, at a certain point, forget himself in problems of pictorial means. By 1650 Rembrandt humbly recognised the pouches on his ageing face as records of weakness and disappointment; but as his brush approached the canvas he forgot everything except how to render their exact colour and tone. Then, as he stood back to contemplate the result, he could see how far from heroic this pictorial obsession had made him. At this point most of us would be tempted to let the two processes overlap; to modify, very slightly, that purplish red on the left eyelid. But the thought never entered his mind. He saw no reason for making himself out to be better or handsomer than his neighbours, who, after all, might have been Our Lord's disciples.

This patient self-scrutiny took him a very long time. Baldinucci, in one of the earliest lives of Rembrandt, tells us that one reason why the number of his sitters declined was the quantity of sittings he demanded, and this is confirmed by the technique of his later portraits. The surface is covered with scumbling, scratching, glazing—every known device in the cookery of painting—and with minute touches of the brush or palette-knife, each put on after the preceding layer was dry. We need no longer ask why he was forced to paint himself; the wonder is that he found anyone else to sit for him, let alone to sit twice, like that patient old beauty, Margaretha Tripp, whose public and private likeness may now be compared in the London National Gallery.

74 Rembrandt: *Self-portrait*, 1650. Washington, National Gallery of Art

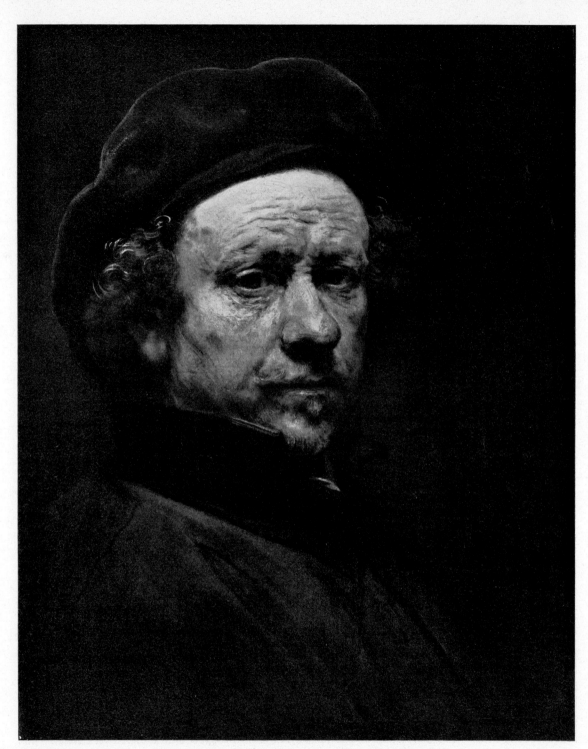

75 Rembrandt: *Self-portrait*, 1657. Ellesmere Collection

Self-Portrait

All Rembrandt's self-portraits convince us that they are absolutely truthful, yet they differ from one another to a surprising extent. In the course of a year his face seems to hollow itself and then fill out again, the wrinkles cover it and then recede and finally return as deeper gashes. Even supposing that the portraits in Aix-en-Provence and the de Bruyn collection were painted during an illness, this variation proves that the most faithful portrait is the expression of the painter's mood. The Kenwood self-portrait is one of the most relaxed of Rembrandt's later works. He looks less worried than usual and a little fatter; and this relaxation is evident also in the technique which, compared with the relentless autopsy of the Ellesmere portrait, is almost easy-going. On the forehead there is a melodious ease of transition from shadow to light, but to the left the concentration becomes more intense, the paint is worked into a thicker paste, and he scores the deepest wrinkle by scratching the surface with the sharpened handle of his brush. This sharp point also scrabbles round the left eye, like a gigantic etching-needle, and is used to indicate his moustache with a scrawl like a carefree signature. Every touch is both a precise equivalent of the thing seen and a seismographic record of Rembrandt's character.

More than any of the series, the Kenwood portrait grows outward from the nose, from a splatter of red paint so shameless that it can make one laugh without lessening one's feeling of awe at the magical transformation of experience into art. By that red nose I am rebuked. I suddenly recognise the shallowness of my morality, the narrowness of my sympathies and the trivial nature of my occupations. The humility of Rembrandt's colossal genius warns the art historian to shut up.

Portrait of the Artist, by Rembrandt (1606–1669), is in oil on canvas, and measures 45″ × 37″ (114.3 × 394 cm.). Painted c. 1663. It was in the possession of the Comte de Vence in Paris in 1750, and was sold in Paris in February 1761. It entered the Hennessy collection in Brussels in 1781, and was sold at the Danoot sale in 1828. It was imported to England by Buchanan and Nieuwenhuys, and sold to the Marquess of Lansdowne in 1836. Bought by the 1st Earl of Iveagh in 1888. It passed to the nation with the rest of the collection at Kenwood under his will in 1927.

SOURCES OF PHOTOGRAPHS

Agraci, Paris, 57; Anderson, Rome, 5, 7, 8, 10, 11, 13, 43; Annan, 75; Osvaldo Bohm, 2; Boston, Museum of Fine Art, 53; British Museum, 40, 41, 72, 73; J. E. Bulloz, 25, 64; A. C. Cooper Ltd, 27, 42; Courtauld Institute, 49; Danesi, Rome, 58; Deutsche Fotothek Dresden, 35; Fine Art Photography Ltd, 1, 3, 16, 63, 65, 66, I, II, III, V, VI; Giraudon, 62; M. Hours, 61; Kunst-historisches Museum, Vienna, 33; Lefevre Gallery, 48; London County Council, 71; Mansell Collection, 4, 9, 15, 60; Mas, Barcelona, 28, 29, 30, 31, 32; Moreno, Madrid, 46; National Gallery, London, 6, 34, 36, 47, 51, 56, 67, 68, 70; National Gallery of Art, Washington, 74; Phaidon Press Ltd, IV; Prado, 14; Städtische Kunsthalle, Mannheim, 45; Städelsches Kunstinstitut, Frankfurt, 12; Walter Steinkopf, 22, 23, 24, 26; Tate Gallery, 54, 55; Uffizi Gallery, 59; Victoria and Albert Museum, 17, 18, 19, 20, 21, 37, 38, 39; Vizzavona, Paris, 50; Royal Library, Windsor, 52.